THE NATIONAL GALLERY

AN ILLUSTRATED
HISTORY

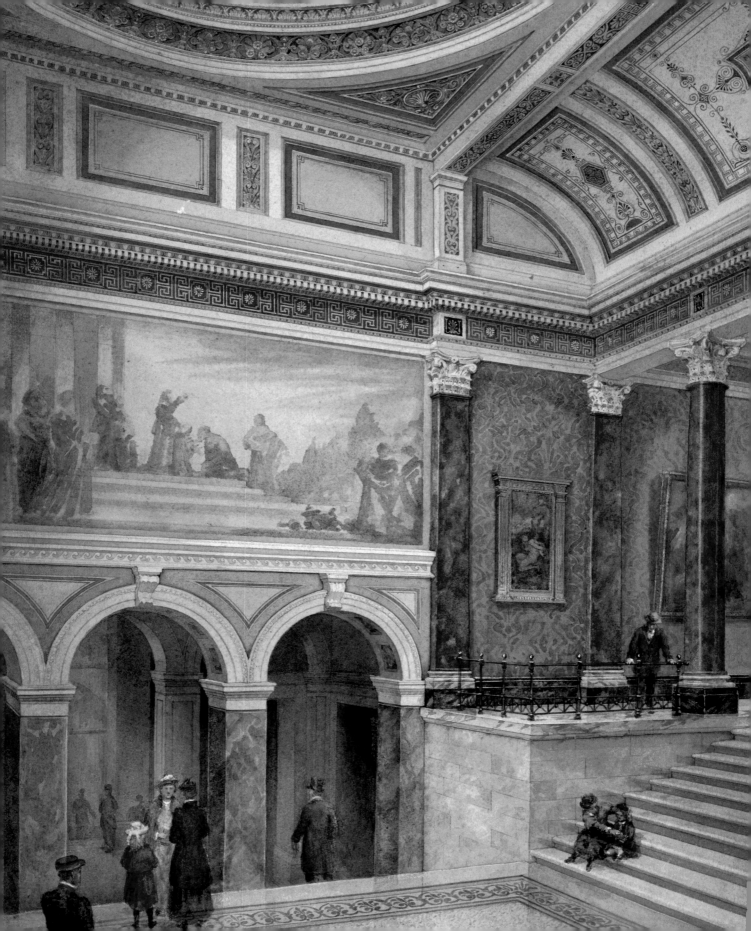

THE NATIONAL GALLERY

AN ILLUSTRATED HISTORY

ALAN CROOKHAM

NATIONAL GALLERY COMPANY, LONDON
DISTRIBUTED BY YALE UNIVERSITY PRESS

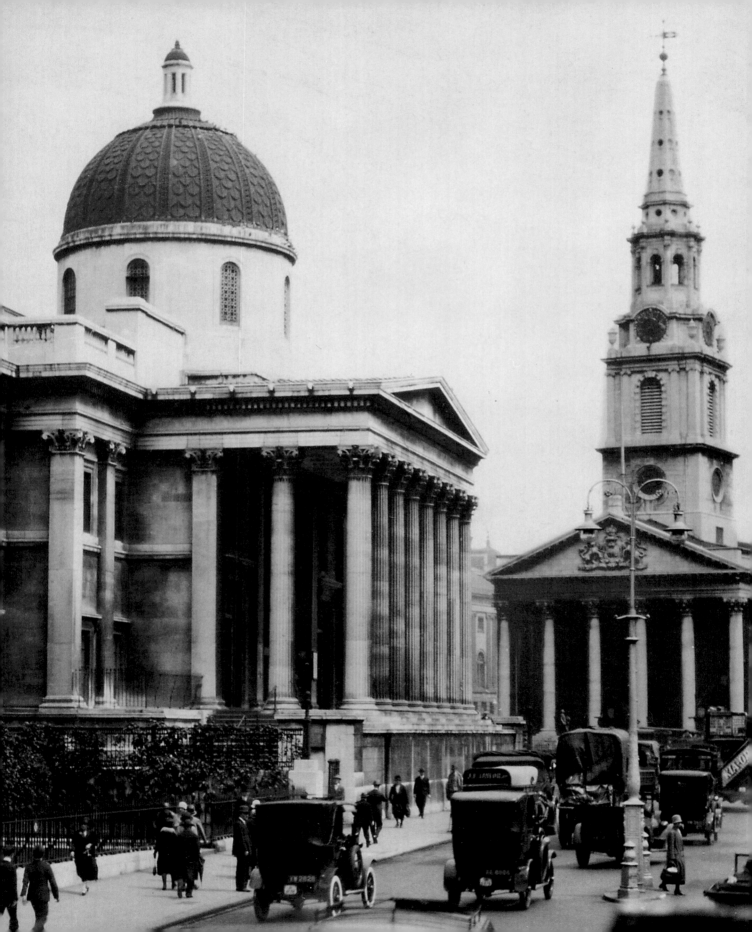

Contents

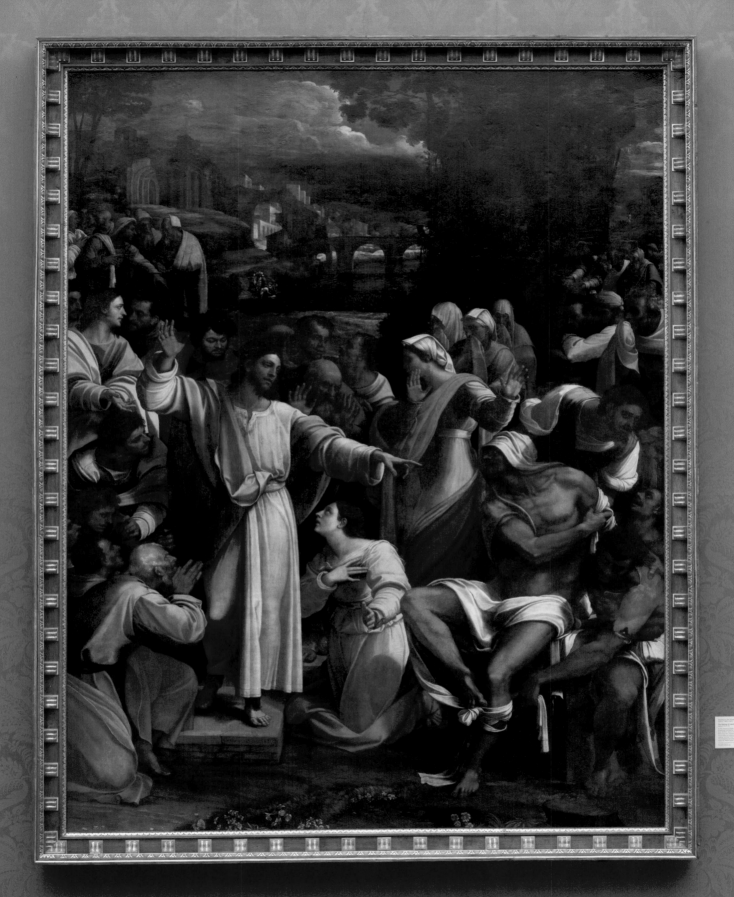

Art for the Nation

The National Gallery opened its doors to the public for the first time on 10 May 1824. The story of its foundation is one of enlightened minds, generous benefactors, and opportunities made and lost: a story that continues to the present day.

The end of the eighteenth century witnessed a growing interest in the establishment of national collections of art across Europe. It was France that led the way when it opened the royal collection in the palace of the Louvre as a museum in 1793. The Dutch followed with the Rijksmuseum in 1800 and the Spanish with the Prado in 1819, but the British still had no national gallery of art at this time. Early initiatives to establish a national collection had not met with success. For example, in 1777 the MP John Wilkes had proposed that Sir Robert Walpole's paintings, known as the Houghton Collection, should form the basis of a national gallery within the British Museum. Wilkes's proposal was rejected and the Houghton Collection was sold abroad to Catherine the Great of Russia in 1779. In the ensuing decades calls for a national gallery grew louder, particularly in the early 1800s, after British travellers had experienced the art treasures amassed by Napoleon in the Louvre. It wasn't simply a case of emulating the French. Although national pride was at stake, more importantly there were many who felt that a national gallery was a necessary educational tool to improve British design. Improved designs would be beneficial to British manufacturing, which in turn would be beneficial to the British economy. At the same time an accessible gallery of Old Master paintings would serve as an invaluable resource and inspiration for the education of contemporary British artists.

BELOW Idealised view of the Grande Galerie of the Louvre in 1796 by Hubert Robert. Established in 1793 and enlarged by Napoleon in the early 1800s, the museum at the Louvre was a source of encouragement and inspiration for early supporters of a British national gallery.

OPPOSITE LEFT John Hoppner, *Sir George Beaumont*, 1803. Sir George Beaumont (1753–1827) was an early advocate of the National Gallery and donated 16 paintings to the collection in 1826. He was a collector of both Old Masters and contemporary works, but his taste did not extend to more radical artists such as Turner.

OPPOSITE RIGHT Sir Thomas Lawrence, *John Julius Angerstein, aged about 55*, about 1790. Angerstein had been born in St Petersburg, Russia, in 1735 and came to England in 1749, where he enjoyed great commercial success in the insurance business and went on to become Chairman of Lloyd's of London. By the time of his death in 1823, Angerstein had built up an impressive collection of paintings which, in 1824, the Government purchased from his estate to form the nucleus of the new National Gallery.

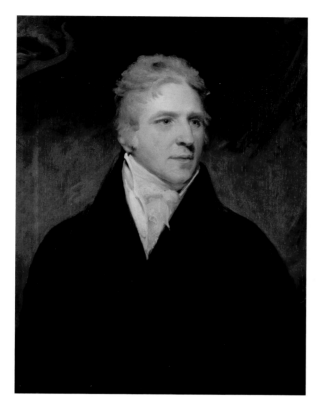
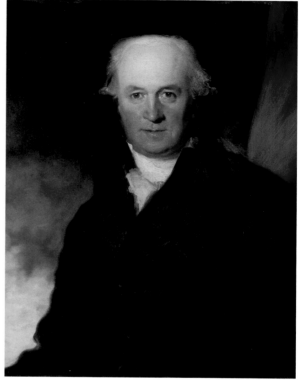

One of the key figures calling for a British national gallery was the wealthy collector and amateur artist Sir George Beaumont. In 1823 Beaumont focused attention on the issue by offering to give his own collection of pictures to the nation, provided that suitable accommodation was made available for its display. The matter received a further impetus when, in that same year, another highly prized collection came onto the market, that of the wealthy banker John Julius Angerstein. Guided by the renowned portrait painter Sir Thomas Lawrence, Angerstein had built up a small yet select collection of 38 paintings. When he died, in 1823, many feared that his outstanding collection would be sold abroad in similar circumstances to the Houghton

Collection more than 40 years earlier. Both the offer by Beaumont and the threatened loss of Angerstein's paintings stirred the advocates of a national gallery into action and they called upon the Prime Minister, Lord Liverpool, to purchase the Angerstein Collection for the nation.

By happy coincidence, in 1824 Lord Liverpool happened to have an unexpected source of income at his disposal. In the 1790s the Government had advanced two loans totalling more than £6 million to Austria to bring the Austrians into the war against France. After more than 20 years the money had been all but written off, until in 1823 the Austrians made an unexpected partial repayment of the war loans. The Government

BELOW A print showing the fighting between French and Austrian troops at Ebelsberg bridge, near Vienna, on 3 May 1809, prior to the Battle of Aspern-Essling. Britain supported a number of coalitions against France from the 1790s until the Battle of Waterloo in 1815. It was Austria's partial repayment of huge war loans that provided the British Government with the funds to establish the National Gallery.

OPPOSITE LEFT Sir Thomas Lawrence, *Lord Liverpool*, 1827 (on loan from the National Portrait Gallery, London). Robert Jenkinson, 2nd Earl of Liverpool (1771–1828), was Prime Minister and a founding member of the 'Committee of Six Gentlemen', which evolved into the Board of Trustees, the governing body of the National Gallery.

OPPOSITE RIGHT John Jackson, *William Seguier*, 1830. Seguier (1772–1843) was the first Keeper of the National Gallery, his tenure lasting from 1824 until his death in 1843. He was appointed on 31 March 1824 on a salary of £200 per annum.

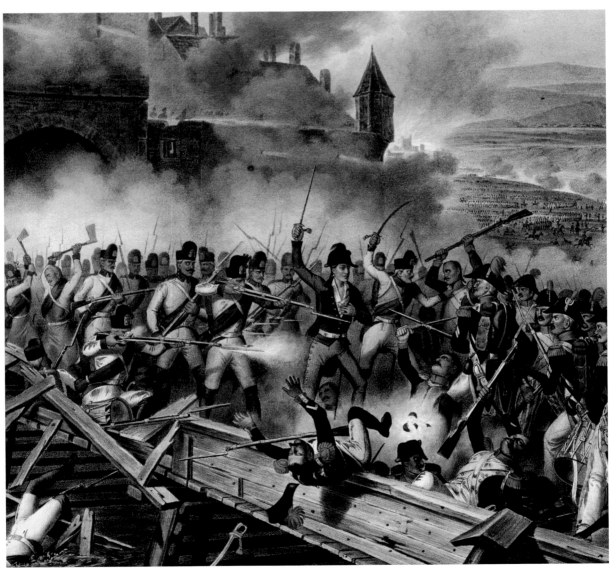

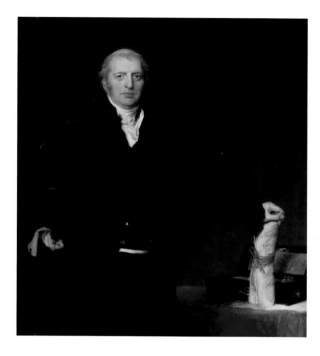

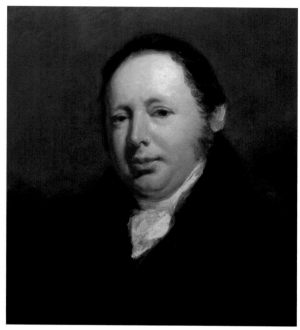

decided to use this sudden bonanza for a number of philanthropic purposes and consequently, in April 1824, the House of Commons voted £60,000 for the purchase, upkeep and exhibition of the Angerstein Collection. A total of £57,000 was paid for the pictures themselves, while part of the remainder was used to secure the lease on Angerstein's house in Pall Mall, which would be the first home of the newly created National Gallery. Supporters of a national gallery were jubilant, including the MP George Agar Ellis who informed the House that 'no private collection of pictures could be better suited to form the basis of a national gallery'.

The Angerstein Collection was now the national collection; and, almost uniquely in Europe, it was derived not from a royal gallery but from a vote of Parliament. The public could now enjoy such masterpieces

as Sebastiano del Piombo's *The Raising of Lazarus*, Hogarth's *Marriage A-la-Mode* series and Claude's *Seaport with the Embarkation of the Queen of Sheba*. Responsibility for the paintings was entrusted to the Keeper, William Seguier, and the Treasury appointed a 'Committee of Six Gentlemen', drawn from both major political parties, to run the Gallery. Their number included Beaumont, who in 1826 fulfilled his earlier promise to donate his collection to the nation. The Beaumont Gift of 16 paintings included Claude's *Landscape with Narcissus and Echo*, Rubens's *A View of Het Steen in the Early Morning* and Canaletto's *The Stonemason's Yard*. Although Beaumont died shortly afterwards, on 7 February 1827, he had lived just long enough to see his paintings join those of Angerstein as the nucleus of the new National Gallery.

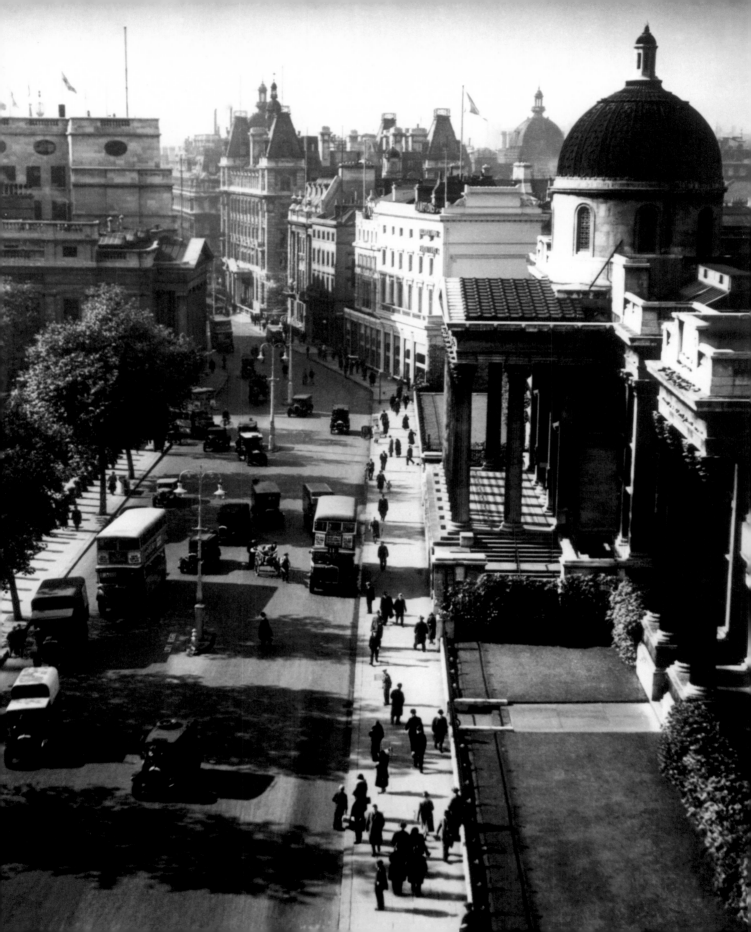

Grand Designs

The Gallery occupies one of the most prominent sites in London. It has become a much loved building stretching elegantly across the northern side of Trafalgar Square. In the early years, however, its detractors far outnumbered its admirers. If the critics had held sway, the view across Trafalgar Square would have been very different.

Trafalgar Square did not even exist when the National Gallery was established in 1824 and there was no grand building ready to house the new national collection. Instead the paintings were put on display in their existing home at 100 Pall Mall, the house that had belonged to John Julius Angerstein and which had been acquired with his collection. As the collection grew, so too did the need for more space to house it and as early as 1828 the Gallery's Trustees were starting to ask the Government for additional gallery space.

At the same time proposals were being made for the redevelopment of the area around Charing Cross. The site had previously housed the Royal Mews but these had fallen into disrepair. The remaining buildings were ramshackle and dilapidated, with the single exception of the stables designed by William Kent in 1732. George IV's favourite architect, John Nash, had already put forward plans to improve the area by the creation of a grand public square and the site soon became one of several possible locations for a new National Gallery. In 1831 the Trustees approved plans drawn up by the architect William Wilkins to replace Kent's stables with a building that would house both the National Gallery and the Royal Academy. Government support was forthcoming and the following year Wilkins won a public competition for the design of the new Gallery.

LEFT **A view of the National Gallery from the tower of St Martin-in-the-Fields, 1920s. Canada House is visible in the upper left of the photograph.**

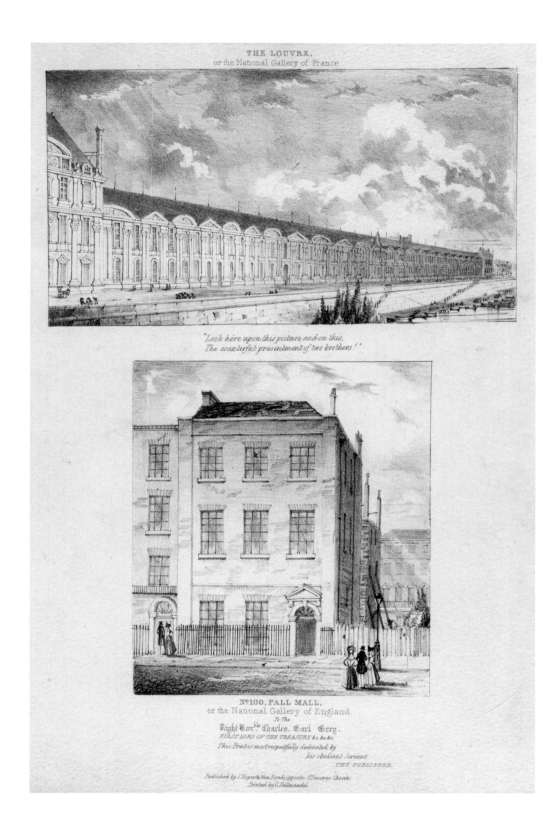

THE LOUVRE.
or the National Gallery of France

"Look here upon this picture, and on this,
The counterfeit presentment of two brothers!"

Nº 100, PALL MALL.
or the National Gallery of England

To The
Right Honble Charles Earl Grey.
FIRST LORD OF THE TREASURY &c &c
This Print is most respectfully dedicated by
his obedient Servant
THE PUBLISHER.

Published by J. Hogarth New Road, opposite St Pancras Church
Printed by C. Hullmandel

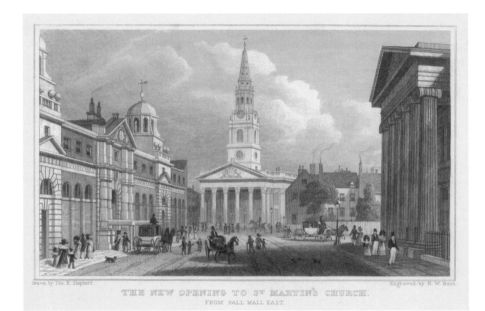

THE NEW OPENING TO ST MARTIN'S CHURCH.
FROM PALL MALL EAST

Drawn by Tho. H. Shepherd. Engraved by H. W. Bond.

However, no sooner had he achieved success than Wilkins found his plans the subject of criticism. There were those who believed that the height of the building was too low for the grand square it was intended to dominate; others were dismayed that the Gallery would block a clear view of the church of St Martin-in-the-Fields and consequently the Gallery had to be moved 50 feet back from its original proposed site. The issue of cost also posed problems. A primary reason for Wilkins's success had been the relatively low cost of his design but, as he sought to answer his critics with a more elaborate scheme, costs soon began to escalate and economies were demanded. For the columns at the front of the Gallery Wilkins was compelled to rework bases and capitals from the columns of Carlton House, the former home of the Prince Regent, which had since been demolished. Wilkins's intentions to place sculpture on the building

were scaled back and the figures that were used were reclaimed from those carved for the Marble Arch (at that time sited in front of Buckingham Palace) but not used when that project too had run over budget. This involved certain modifications, which included the transformation of the Marble Arch's Britannia into the National Gallery's Minerva, Goddess of Wisdom. Originally designed by John Flaxman, the statue was conceived as a seated figure of Britannia to appear on the Marble Arch brandishing a trident and shield. The shield was to bear the head of Nelson, commemorating British victories over France. After Flaxman's death in 1826 the work was taken over by Edward Hodges Baily, who also carried out the alterations required by Wilkins to convert the statue into Minerva, most notably chipping off the head of Nelson from the shield and exchanging a spear for the trident. At the same time the need to complete the building became

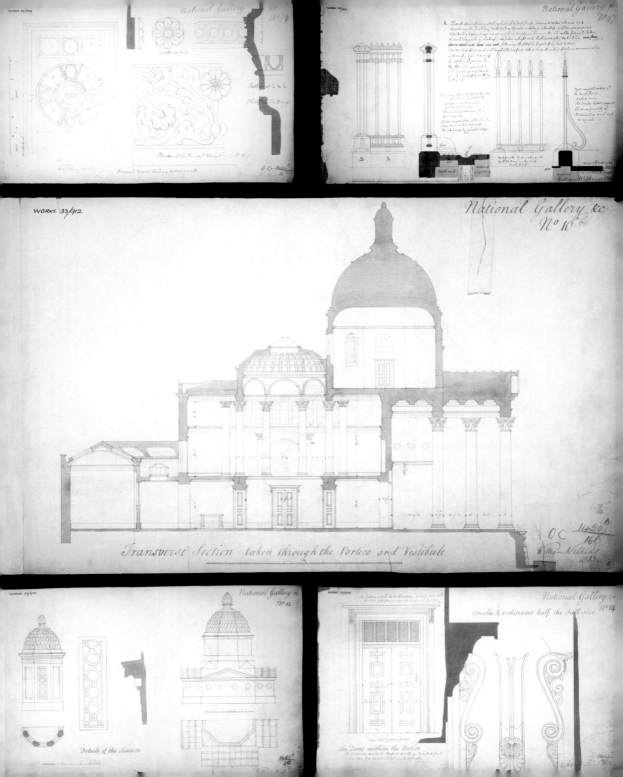

National Gallery &c
Nº 9

National Gallery &c
Nº 7

National Gallery &c
Nº 10

National Gallery &c
Nº 12

National Gallery &c
Consoles & architraves half the full size
Nº 14

WORKS 33/909

WORKS 33/912

WORKS 33/912

WORKS 33/917

WORKS 33/908

Details of the Newels

Transverse Section taken through the Portico and Vestibule

The Doors within the Portico

William Wilkins 1833

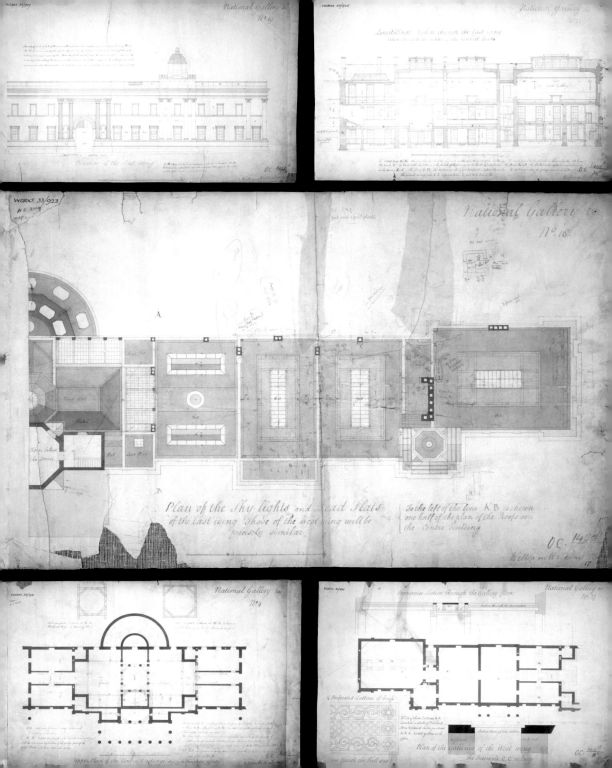

increasingly urgent after the Gallery was forced to move into temporary accommodation at 105 Pall Mall in 1834, when excavations for the construction of the neighbouring Carlton Club had weakened the structure of Angerstein's house. Despite all the difficulties, after five long years under construction Wilkins's building was finally ready to house the National Gallery and on 9 April 1838 it opened its doors to the public.

Wilkins's façade remains much now as it was originally but, inside, visitors would have been greeted by a large entrance hall with staircases rising on either side. Ascending to the left, visitors would enter the National Gallery in the west wing, and to the right the Royal Academy in the east wing. The opening of the building, however, failed to stop the critics who continued to find fault both with

the building's architecture and its failure to provide adequate space for the collection. *The Times* summed up the general mood when it stated that 'it is generally known that the rooms in which the pictures are hung are but badly calculated for the purpose, and that the interior of the place is more than commensurate in defects with the absurdities and bad taste of the outside'.

While critics were unimpressed by the architecture of the building, the greatest concern for the Gallery was that it was simply not large enough to display the collection. This problem became ever more pressing as the number of acquisitions continued to grow. Temporary measures included housing the collection of British paintings first at Marlborough House and later at the South Kensington Museum (now

OPPOSITE LEFT Carlton House, Pall Mall, in 1820. After the building had been demolished, the columns were abandoned in the adjacent St James's Park until their bases and capitals were retrieved by Wilkins and incorporated into the new National Gallery building.

OPPOSITE RIGHT The sculptures on the front of the Wilkins building, still visible today, had originally been destined for the Marble Arch. Modifications included the transformation of Winged Victory by the addition of a paintbrush and palette.

BELOW *Cross-Readings at Charing-Cross (With a View of the New National Gallery)*, a hand-coloured engraving of around 1836, showing the Gallery partially encased in scaffolding. The posters pasted up on the hoarding are a revealing insight into attitudes of the time.

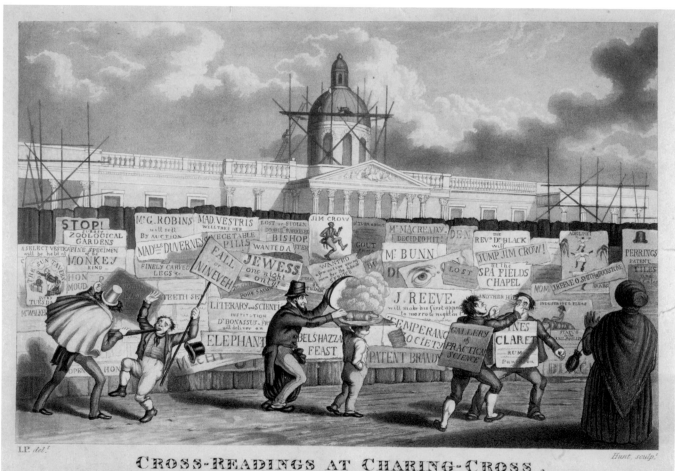

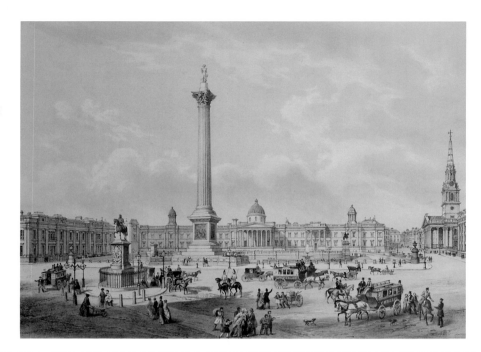

RIGHT **Edmund Walker,** *Trafalgar Square, with the National Gallery, and St Martin's Church*, 1852 (lithograph). The square was laid out in the 1840s according to designs by Charles Barry. Nelson's Column was designed by William Railton and the statue of Nelson, sculpted by Edward Hodges Baily, was lifted into position in November 1843. Although part of the original design, Sir Edwin Landseer's lions at the foot of the Column were not added until 1867.

BELOW **The earliest photograph of the Gallery, a daguerreotype dating from 1839.**

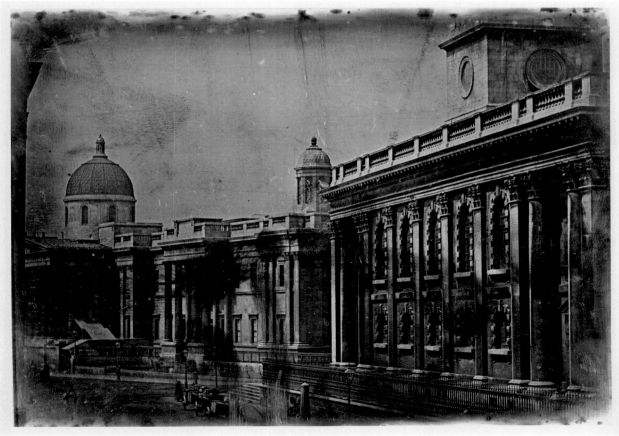

BELOW LEFT The grand
staircase leading to the west
wing of Wilkins's building,
1841, which housed the
National Gallery.

BELOW RIGHT James
Pennethorne's gallery was
constructed across Wilkins's
entrance in 1861 to provide
much needed extra space for
the Gallery.

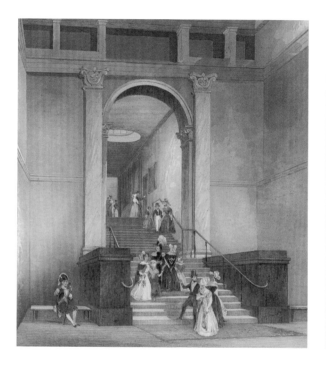

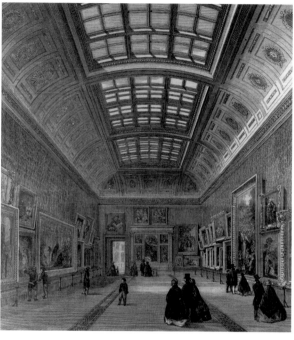

the Victoria & Albert Museum). An extra
gallery designed by James Pennethorne in
1861 and running across Wilkins's original
entrance could only provide momentary relief.
Numerous proposals were made, including
moving the entire collection out of
Trafalgar Square and to a new building
at Kensington Gore. Others suggested
demolishing the entire Wilkins building and
starting afresh. After much debate throughout
the 1840s and 1850s, a decision was finally
made to leave the Gallery in Trafalgar Square
but it was by no means certain that it would
continue to be housed in the original
Wilkins building.

In 1866 a competition was launched in
which architects were invited to submit two
designs: one for a completely new National
Gallery; and the other for a remodelling of
the existing building. The competition was
won by Edward M. Barry in June 1868 but
once again cost considerations delayed any
immediate action and Barry was asked to
submit new designs at the end of 1869 (the
same year that saw the departure of the Royal
Academy to Burlington House). Wilkins's
building remained under threat but ultimately
Barry's plans for a completely new gallery
were rejected as too expensive. Instead, Barry
was commissioned to design a suite of galleries

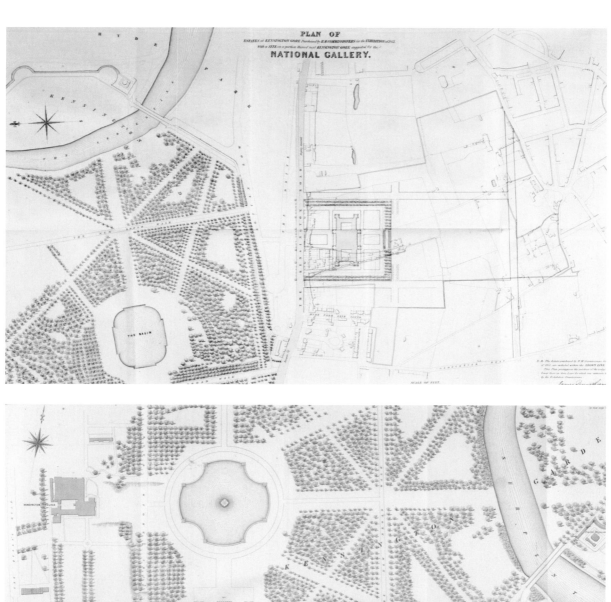

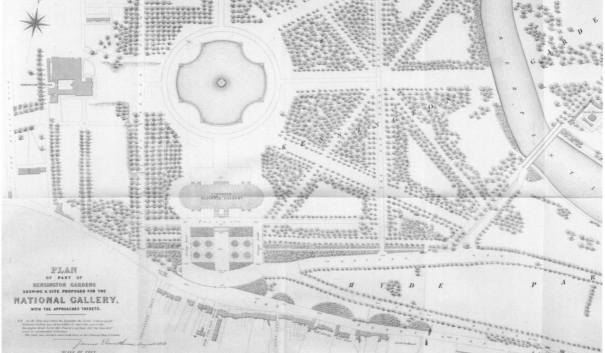

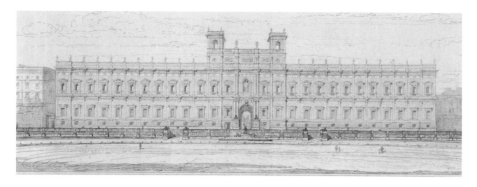

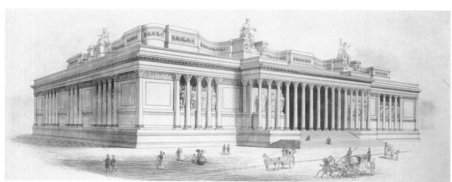

OPPOSITE Two proposed sites for a new National Gallery at Kensington Gore (now known as Kensington Gardens). Plans date from 1853.

THIS PAGE Throughout the mid-nineteenth century architects put forward numerous alternative designs for the National Gallery and its expanding collection, including proposals by (from top to bottom) Charles Barry (1833), Alexander Lauder (about 1866) and Henry Ashton (1848).

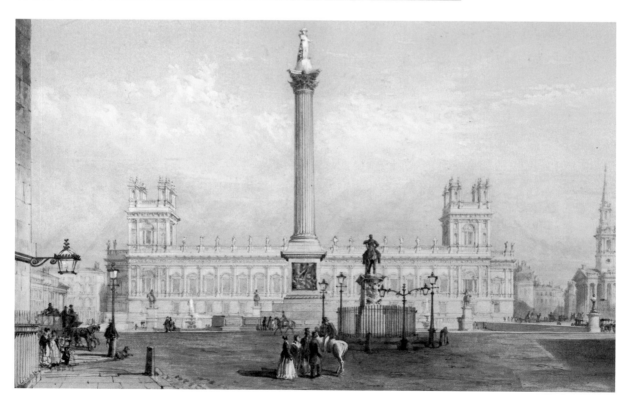

as an extension to the existing building, which is still known today as the Barry Rooms. Construction finally started in 1872 and was completed four years later. The Barry Rooms consisted of eight galleries to the north-east of Wilkins's building and included an octagonal gallery as their focal point. The rooms set the pattern for future extensions. A new central hall in 1887 provided the Gallery with a spine from which further rooms were added to the north-west of Wilkins's building in 1911, mirroring those designed by Barry. The further addition of the Mond Room and the Duveen Gallery in the late 1920s largely completed this process. The Wilkins building now fronted a complex series of galleries which stretched back from Trafalgar Square over a large rectangular site.

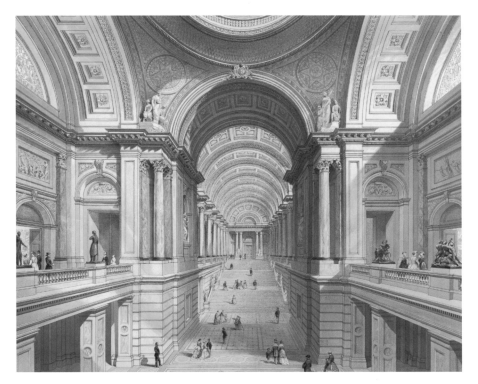

LEFT Edward M. Barry's design
for a new National Gallery,
about 1872. The designs for a
completely new building were
rejected as too expensive and
Barry was instructed, instead,
to add an extension to the
existing building. This was
completed in 1876.

BELOW Visitors enjoying
the new Barry Rooms,
captured in this painting by
Giuseppe Gabrielli.

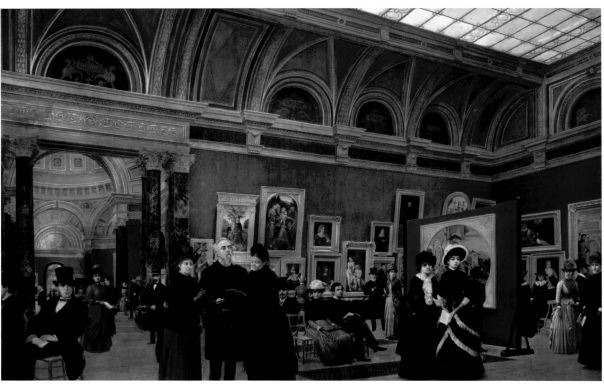

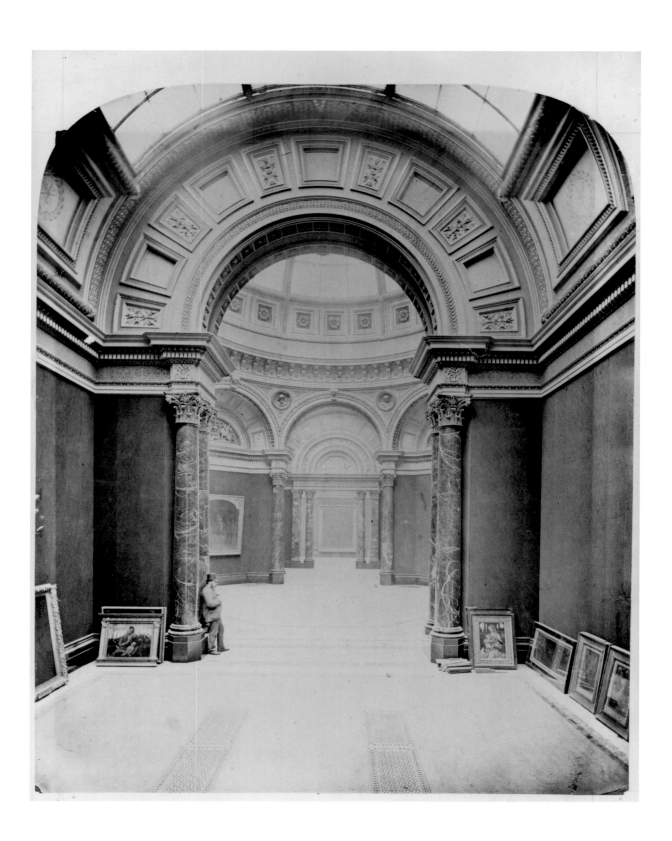

OPPOSITE The newly completed Barry Rooms in 1876, waiting for the pictures to be hung. Left of the arch is Giovanni Bellini, *Madonna of the Meadow*, about 1500, and right of the arch is Lorenzo di Credi, *The Virgin and Child*, 1480–1500.

LEFT An extension of the Gallery in 1911 shows how further expansion mirrored the layout of the Barry Rooms.

BELOW The Duveen Gallery, opened by Prince George on 9 January 1930, was the last major addition to the building before the Second World War.

OVERLEAF View of Trafalgar Square looking north to the National Gallery, about 1900.

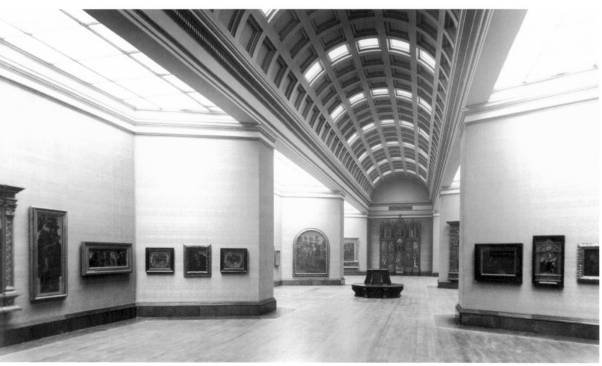

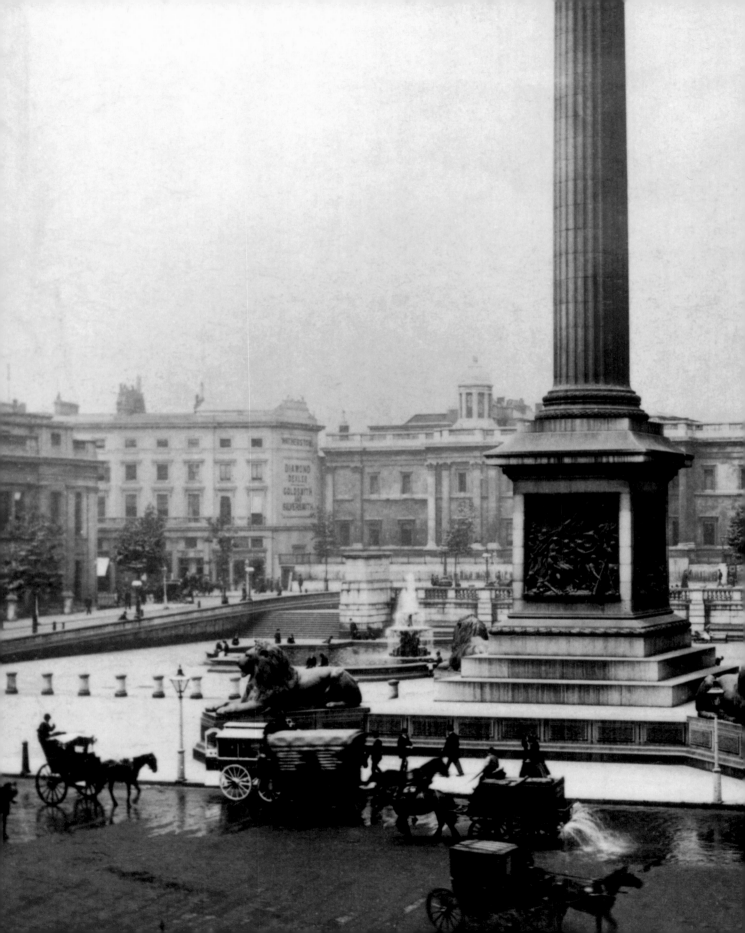

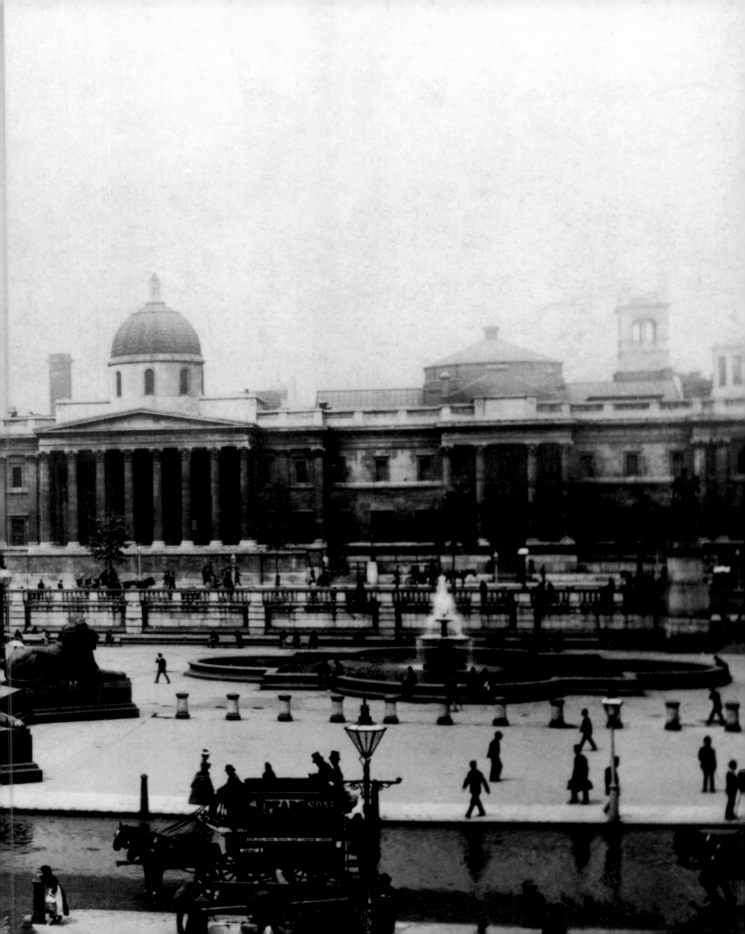

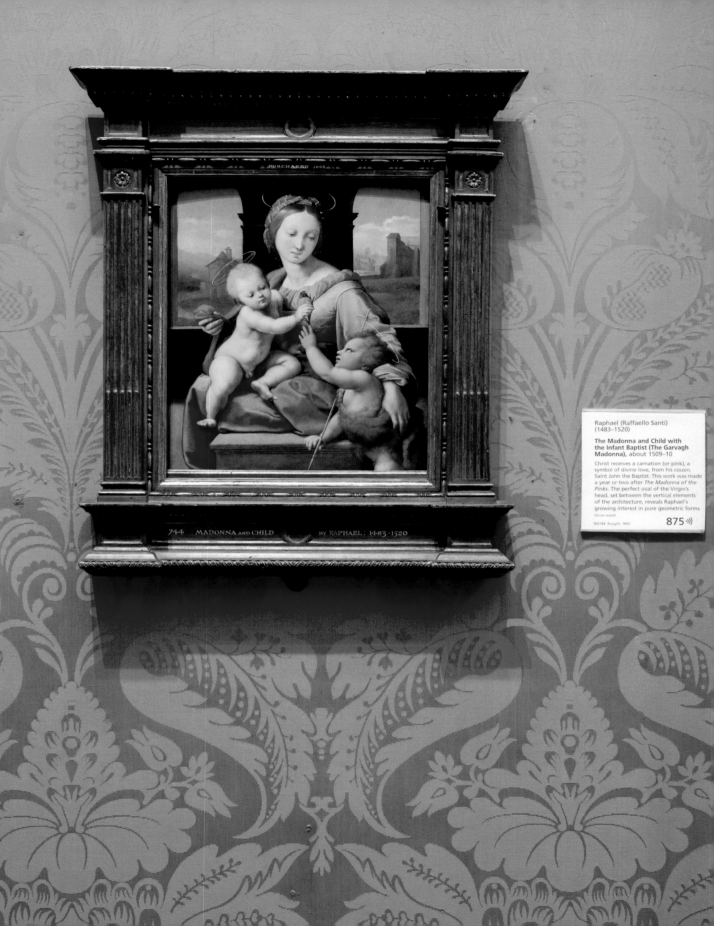

744 MADONNA and CHILD BY RAPHAEL; 1483–1520

Raphael (Raffaello Santi)
(1483–1520)

**The Madonna and Child with
the Infant Baptist (The Garvagh
Madonna),** about 1509–10

Christ receives a carnation (or pink), a
symbol of divine love, from his cousin,
Saint John the Baptist. This work was made
a year or two after *The Madonna of the
Pinks*. The perfect oval of the Virgin's
head, set between the vertical elements
of the architecture, reveals Raphael's
growing interest in pure geometric forms.
Oil on wood

NG744 Bought, 1865 875))

A Journey through Europe

Although the number of works in the collection increased during its first 30 years, it was a haphazard growth that led many people to call for reforms to the Gallery's structure. As a result, in 1853 the Government launched an inquiry into the Gallery's affairs. It was all too apparent that improvements needed to be made and that the Gallery required a clear acquisitions policy. Two years later reforms were put into place and a powerful new position of Director was created. Its first incumbent was also to be one of its greatest: Sir Charles Lock Eastlake.

Eastlake was no stranger to the National Gallery. As a painter, collector and early exponent of art history, he had already served as Keeper of the Gallery between 1843 and 1847; and, as President of the Royal Academy, he sat as an *ex-officio* Trustee from 1850 to 1855. As Keeper, Eastlake had been frustrated by the lack of an annual purchase grant and the ill-defined division of responsibilities between his role and that of the Trustees. As Director, Eastlake would no longer have to face such difficulties. He now had the resources and the authority to conclude negotiations for the acquisition of works and was actively encouraged to seek out paintings from abroad in order to ensure that the Gallery fully represented the history of western European painting. In addition, he could count on the support of two new Gallery officials: Ralph Nicholson Wornum, an art historian who had travelled extensively in Europe visiting the major art collections, as Keeper and Secretary; and Otto Mündler, a German art dealer who had been based in Paris, as Travelling Agent.

LEFT Raphael, *The Garvagh Madonna*, about 1509–10. Bought 1865.

LEFT Sir Charles Lock Eastlake (1793–1865), first Director of the National Gallery, 1855–65. Eastlake was an influential figure in the art world of mid-nineteenth century Britain. An artist and collector, he also held numerous senior positions, including President of the Royal Academy, Secretary of the Fine Arts Commission and Keeper and Director of the National Gallery.

TOP RIGHT Ralph Nicholson Wornum (1812–1877), Keeper of the National Gallery from 1855 until his death. The Keeper supervised the day-to-day administration of the Gallery and was responsible for the compilation and publication of the catalogues of the collection.

BOTTOM RIGHT Lady Elizabeth Eastlake, née Rigby (1809–1893). She and Sir Charles Eastlake were married in 1849. An accomplished art historian and linguist, Lady Eastlake's achievements included the English translation of the German art historian Gustav Waagen's *Treasures of Art in Great Britain*.

OPPOSITE A page from Otto Mündler's diary. Mündler (1811–1870) was the Gallery's Travelling Agent until Parliament abolished the post in 1858. His duties were to inspect paintings on the Continent in order to ascertain their suitability for the collection and to keep the Gallery informed of any possible sales. In his travel diary he recorded details of works of art that might be offered for sale.

Diary.

<u>Paris.</u>

August 16th 1855. Went to Rue de Rivoli 150, at Sign. Paris
Gastaldi's, to see a collection of italian pictures, among which
there was particularly recommended a Seb. del Piombo. found
nothing worth looking at — the Sebastiano del P. a wretched copy
from the picture by this master in Mr Galleany collection in Paris. Appendix 1.

 The same day went to see a collection of italian pic- Property of Signor
tures at M. Carini's, Boul. des Italiens, 4. found several Delavo from Marengo.
interesting pictures, which on the

 16th I returned to examine. Detailed account in Appendix II.
The pictures really interesting in this collection are No 20 van
Dyck, Virgin and Child, size of life, from the Collect. of Marchese
Cambiane in Turin. The master's Genovese stile. Virgin very fine
Child not elevated in character, too portraitlike. free execution,
but not all the parts equally finished. Good date. 30,000 F.
asked. — No 21. Titian, sketch of the "Farnoute sommerso", the well
known composition, which T. painted in the ducal Palace, &
which was destroyed by the fire in 1577. V. Della pitt.
verage. Lib. L.II. p.104. this composition is engraved on wood,
from Titian's drawing — Ridolfi, maraviagl. dell' arte, I. 183 — by
"Domenico dalle greche dipentore Veneziano MDXLIX-" in 12 leaves.
The painting is very fine and quite titianesque in colouring & in the
character of the heads. Some parts however have suffered and are
restored. Part of the sky seems to be cut off. Price demanded 18,000 F.
No 22. Guercino portrait of himself with palette and brushes,
 starchy

 1

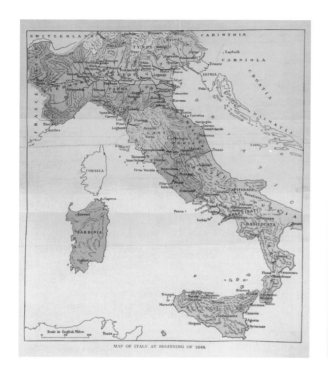

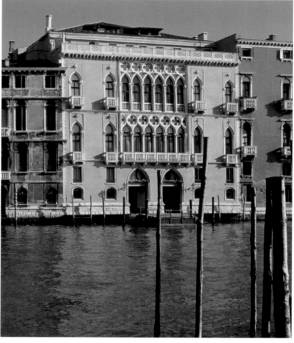

MAP OF ITALY AT BEGINNING OF 1848.

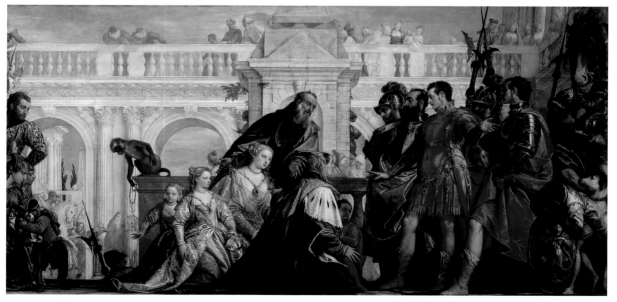

Following his appointment as Director in July 1855, Eastlake immediately set about his task and sought to remedy the Gallery's poor record of acquisitions on the Continent by undertaking the first of many journeys to Europe. In August he set out for Paris accompanied by his wife, Lady Eastlake, who herself was an accomplished scholar, writer and linguist. From Paris the Eastlakes travelled on to Strasburg and Karlsruhe, and thence to Italy via Switzerland. During his travels Eastlake kept meticulous notes of the paintings that he inspected in collections and galleries. On this journey alone his notes covered visits to Bergamo, Milan, Parma, Florence, Pisa, Bologna, Lucca, Ferrara and Venice. At times Eastlake would purchase a painting there and then; at other times he would put down a marker for future negotiations. All the while he had to contend with the financial expectations of vendors, the differing export regulations of the various Italian authorities, and the competition for paintings from other collectors, both public and private.

The difficulties facing Eastlake are exemplified by his lengthy negotiations to acquire Paolo Veronese's masterpiece *The Family of Darius before Alexander*. While in Venice in 1855, Eastlake made an offer of £8,000 for the painting, which belonged to Count Pisani and hung in his *palazzo* on the Grand Canal. Although the offer was rejected, it was believed that the Count would sell if the right price were offered, despite the fact that the picture had been in the Pisani family since it was painted in the 1560s. The Eastlakes returned to England but the following year Mündler, the Gallery's Travelling Agent, was dispatched to continue negotiations. He arrived in Venice on 1 August 1856. Time was of the essence as it was rumoured that both the French and Russian Governments were also interested in the painting. In London, Eastlake expressed his concern that 'no specimen of that master of equal excellence and celebrity is likely to be for sale again'. Negotiations were protracted and difficult, complicated further by the Count's domestic situation. After the death of his only son, the Count's property stood to be inherited by his three daughters and their husbands. There were fears among the family that the painting could be left to one daughter to the exclusion of the other two. In addition,

members of the Count's household, who had made a good living showing the painting to visitors, would lose income if the painting were removed from the *palazzo* without any monetary gain for them. It was therefore in the interests of all the parties to achieve a sale in which they also derived part of the profit. If the Count sold or bequeathed the painting without their involvement, they stood to lose everything. The British Consul-General in Venice, George Harris, summed up the situation: 'thus many persons who have daily and hourly access to the Count, are united by a common mistrust of each other, and by a common expectation of gain, in preventing his treating for the sale of this painting without their knowledge.' The Count vacillated over the winter but eventually a deal was struck in March 1857. The Count accepted an offer of 360,000 Austrian *livres* (£12,280); payment to be made within the month and in silver coins. A further 39,000 Austrian *livres* would be paid to the Count's dependants and agents as commission and gratuities. The sale was concluded on 31 March 1857 and Harris took possession of the painting. However, one outstanding matter remained: the British still needed an export licence. As Venice was then governed by Austria, permission to export the painting would need to come from Vienna. Although the Imperial Austrian Government had assured the British authorities the previous year that they would raise no objections to its export, disquiet in Venice at the loss of such a celebrated masterpiece made for a tense few months. It was not until late June that an export licence was finally granted and on 14 July the steamship *Euphrates* set sail from Trieste with the painting on board, arriving in Liverpool on 7 August. Although the acquisition was a triumph for both Eastlake and Mündler, it was to ultimately cost the latter his job. Questions were raised in the House of Commons about the cost of the acquisition and the gratuities spent in securing it. Despite the fact that Mündler had done nothing wrong and to Eastlake's deep regret, in the summer of 1858 Parliament decided to abolish the post of Travelling Agent.

It was not just the securing of export licences or delicate negotiations with owners that could cause problems – sometimes it was the very subject matter of the paintings themselves. In 1860 Eastlake visited Paris to

conclude the purchase of the Beaucousin Collection, which included Bronzino's sensual *An Allegory with Venus and Cupid*. Eastlake was concerned at how such a painting would be received by his compatriots. Its former owner, Edmond Beaucousin, had the painting covered with a veil, believing it to be 'the most improper picture'. Eastlake felt that 'if the details of the kiss are altered the rest may pass' and it appears highly probable that he ordered some remedial action to mask these details before the painting went on display in London. Restoration work on the painting in 1958 showed that indeed both Venus' tongue and left nipple had been painted out in the nineteenth century. The restoration also showed that an earlier attempt had been made to improve the propriety of the picture by the addition of myrtle leaves as a partial covering of Cupid's bottom and drapery to protect Venus' modesty. Even with such additions, Eastlake still had concerns about how to describe the painting, eventually agreeing with a suggestion put forward by Austen Henry Layard, a future Gallery Trustee: 'I am quite sure that the word "sensual" will not do for either catalogue in the description of the Bronzino – the best title is that suggested by Layard "Venus, Cupid and Time – an Allegory". Depend on it if there is any description which can be quoted and misrepresented you will have clergymen and others interfering and making out a bad case.'

In June 1865 Eastlake began his third five-year term as Director, a term that he was destined never to finish. In August he and Lady Eastlake once again set out for the Continent but on arrival in Milan, Eastlake fell ill. As he was not well enough to return to England, Lady Eastlake decided to nurse him through the winter in Italy. They moved to Pisa in October and it was there, on Christmas Eve 1865, that Eastlake died at the age of 72.

Eastlake left an outstanding legacy of acquisitions, ranging from Uccello's *The Battle of San Romano* to Piero della Francesca's *The Baptism of Christ*, and from Raphael's *The Garvagh Madonna* to Giovanni Bellini's *Agony in the Garden*. The authority he enjoyed as Director passed on to his successors, Sir William Boxall and Sir Frederic Burton. Both continued to enrich the collection. Between 1866 and 1874 Boxall's successes included the purchase of Sir Robert

THIS PAGE AND OPPOSITE
Bronzino, *An Allegory with Venus and Cupid*, probably 1540–50. The work, which was purchased in 1860, had been altered during its previous ownership and was probably further doctored at the behest of Eastlake to render the painting less risqué. The photographs on the left show the painting prior to restoration in 1958; those on the right show the painting as it can be seen today, restored to its original state. The details reveal the parts of the picture that had been painted out to accommodate Victorian sensibilities.

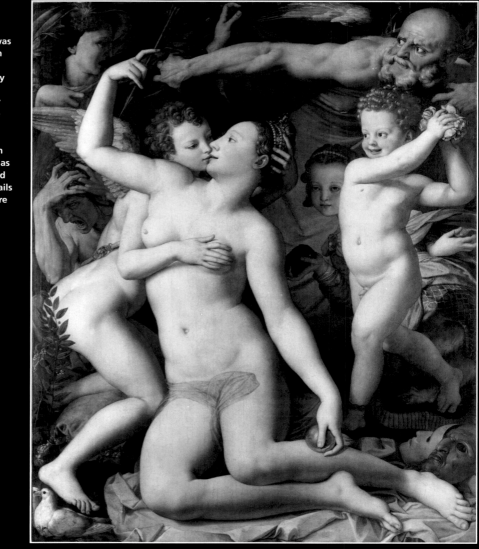

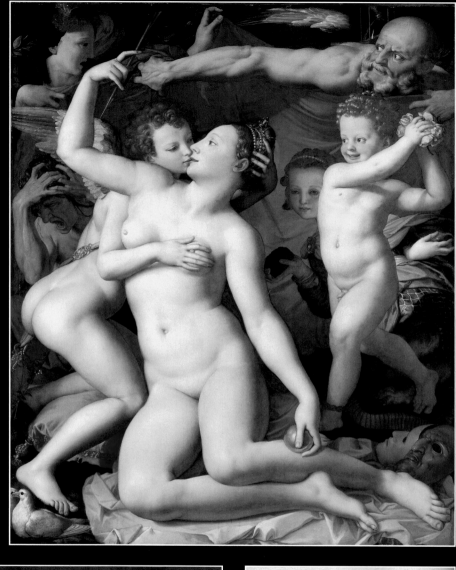

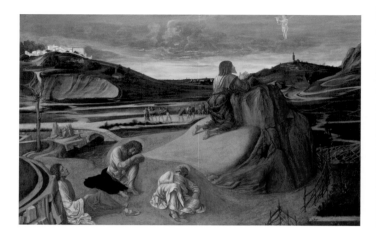

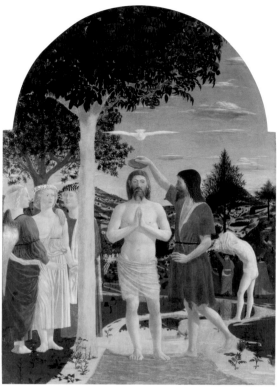

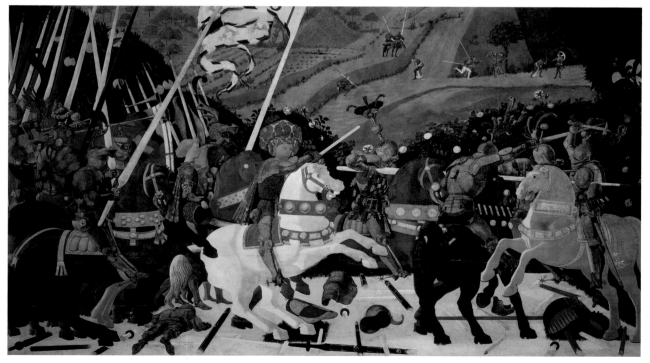

Peel's collection of paintings, which greatly enhanced the Gallery's Dutch holdings, and the acquisition of the Gallery's first painting by Michelangelo, *The Entombment*. Burton took over in 1874 and, during his 20 years as Director, added numerous masterpieces to the collection, including Botticelli's *Venus and Mars*, Velázquez's *Philip IV of Spain in Brown and Silver* and Van Dyck's *Equestrian Portrait of Charles I*. Eastlake had ushered in a golden age that Boxall and Burton carried forward and, by the end of the nineteenth century, they had transformed the Gallery into a truly world-class institution. Whereas the Trustees responsible for acquisitions made before Eastlake became Director were merely concerned to add unquestioned masterpieces to the collection, Eastlake and his successors had recognised the need for the collection to illustrate the history and full variety of European painting. The National Gallery was thus in 1895 rivalled for its comprehensive character only by the great national collection then being formed by its counterpart in Berlin.

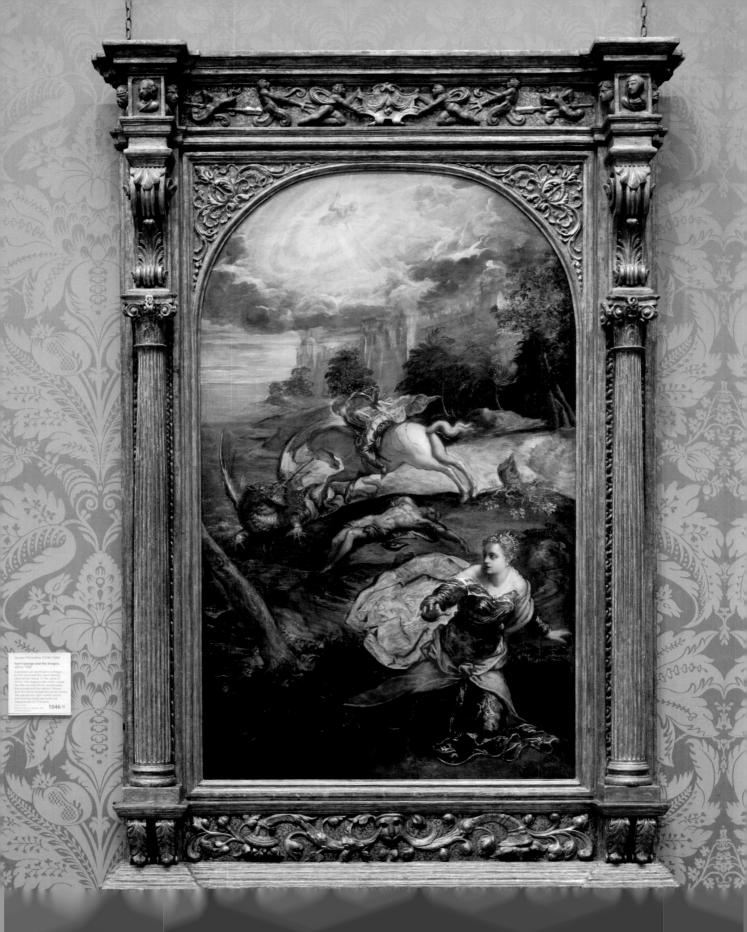

Noble and Patriotic Gifts

Praised by the MP George Agar Ellis as a 'noble and patriotic gift', Sir George Beaumont's generosity in presenting his collection to the nation was to be matched over the years by countless other benefactors. To name but a few, Wynn Ellis, Salting, Layard, Lane and Mond have all played a part in shaping one of the world's great art collections.

From the very start the Gallery benefited from a number of outstanding donations. Only two years after the Beaumont Gift, in 1828 the Duke of Sutherland presented the magnificent Rubens, *Minerva protects Pax from Mars*. The collection was further augmented by the Reverend William Holwell Carr's bequest of 35 paintings in 1831, including Titian's *Holy Family with a Shepherd* and Tintoretto's *Saint George and the Dragon*. The Vernon Gift of 1847 greatly increased the representation of the British School, while the Turner Bequest of 1856 was the Gallery's largest ever donation: 100 finished pictures, 182 unfinished pictures and 19,049 drawings and sketches.

While most bequests were relatively straightforward, occasionally unforeseen problems have arisen. In 1859 the pharmacist Jacob Bell left 19 paintings to the nation, not all of which were immediately delivered to the Gallery. In fact, six years after the bequest there were still two paintings outstanding: Bonheur's *Horse Fair* and Frith's *The Derby Day*. The Director, Sir Charles Eastlake, took the matter up with Bell's executors and learned that Rosa Bonheur had been so delighted to have her painting presented to the National Gallery that she had asked to hold onto it so that she could make another copy. Despite the disapproval of the Trustees, the painting was not relinquished

LEFT Jacopo Tintoretto, *Saint George and the Dragon*, about 1560. Tintoretto's dramatic narrative canvas was one of 35 paintings bequeathed to the Gallery by the Reverend William Holwell Carr in 1831.

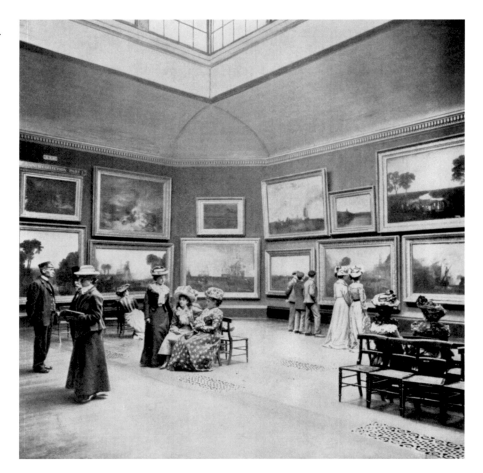

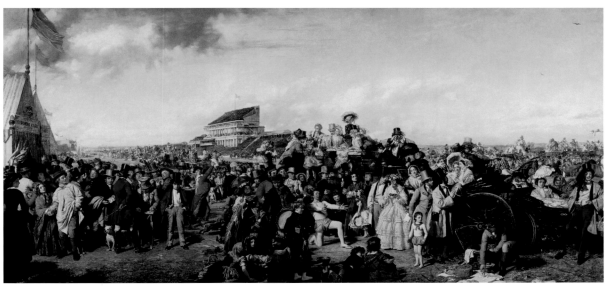

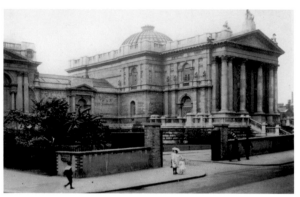

LEFT **Sir Henry Tate (1819–1899) had a highly successful career in the sugar trade. A collector of work by contemporary British artists, he offered his collection to the nation in 1889.**

BELOW **The National Gallery of British Art (now known as Tate Britain) first opened on Millbank as an annexe of the National Gallery in 1897.**

OVERLEAF **A selection of watercolours painted by H.E. Tidmarsh in the 1880s and depicting visitors to the Gallery. Tidmarsh was a topographical artist who painted several views of London in the late nineteenth century.**

by the artist until May 1865. As regards *The Derby Day*, Eastlake discovered that William Powell Frith had entered into an agreement with the dealer E. Gambart. This agreement, which remained valid despite Bell's acquisition and bequest of the picture, allowed Gambart to engrave the painting at his leisure and subsequently exhibit it for a period of five years. As the term had recently expired, the Trustees asked for the painting to be immediately delivered to the Gallery. However, Gambart was unable to meet their demands. Unknown to the Trustees, the painting was many thousands of miles away on the other side of the world. Gambart had sent the enormously popular *Derby Day* on a touring exhibition of Australia and he was therefore forced to explain in May 1865 that

the 'last mail from Australia advises me that my attendant was on his way to Sydney by way of Adelaide and Launceston, he would come home from Sydney after staying there about six weeks according to previous arrangements so that I may expect the picture here in August'. After the long sea voyage back from Australia, the painting finally arrived at the Gallery in November 1865.

Frith's *The Derby Day* was added to the growing number of British paintings in the collection. It was a number that was set to increase even further when in 1889 the wealthy businessman Henry Tate offered the Gallery his collection of 65 paintings of the modern British School. The Trustees were grateful but reluctantly had to turn down the gift as there was simply no space available

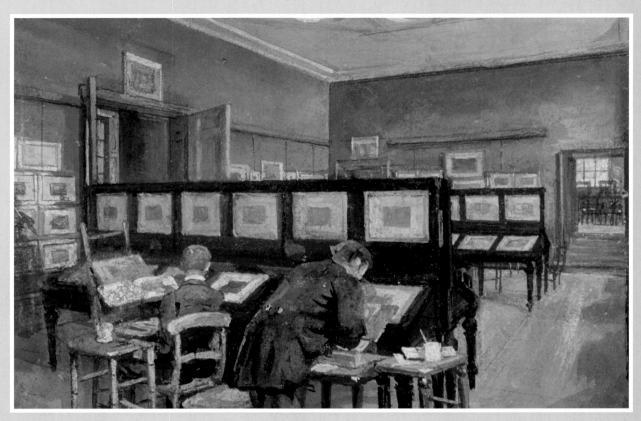

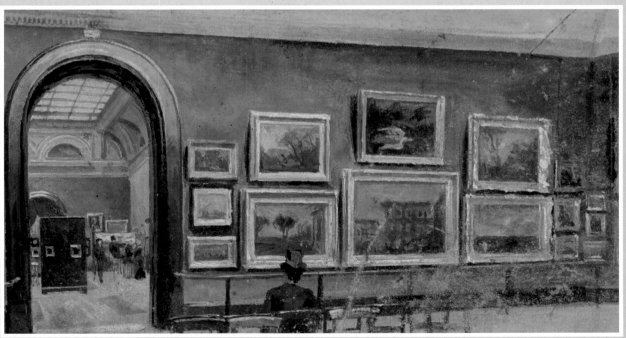

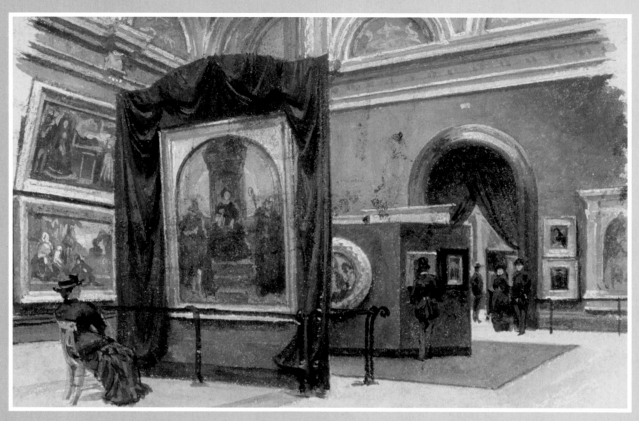

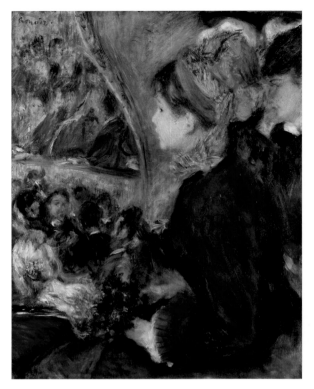

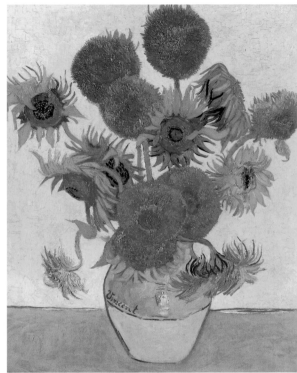

at Trafalgar Square to display the paintings. Therefore Tate revised his offer to include not just his collection but also a separate gallery in which to house it. This new gallery, which would ultimately bear Tate's name, was constructed on the site of the recently demolished Millbank Penitentiary and opened to the public as the National Gallery of British Art in August 1897. Under the control of the National Gallery Trustees, the new gallery contained both Tate's collection and a selection of British paintings from Trafalgar Square. In 1917 its remit expanded to include historic British and modern foreign art and in that year it was given its own Director and Board, although the collection itself remained vested in the National Gallery Trustees.

Renamed the Tate Gallery in 1932, it finally became completely independent in 1955 when the two galleries formally separated.

The majority of the Gallery's British paintings, including the bulk of the Turner Bequest, have now been transferred to Tate, with only a select representation of the British School remaining at Trafalgar Square. Similarly, over the years Tate has transferred nineteenth-century European paintings to the National Gallery once they have ceased to be regarded as modern. Some of the greatest of these paintings were acquired as the result of the extraordinarily far-sighted gift of the textile magnate Samuel Courtauld. In 1924 Courtauld established a trust fund of £50,000 to acquire examples of Impressionist

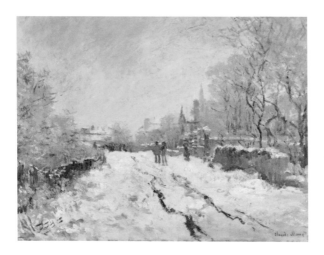

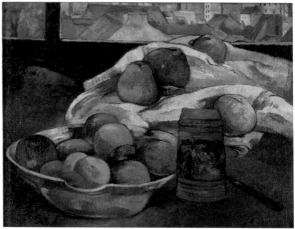

and Post-Impressionist art. Known as the Courtauld Fund, acquisitions were made by five trustees, including Courtauld himself and the Directors of the National and Tate Galleries. The paintings were initially placed at Millbank but Courtauld added that 'any work purchased out of the Fund shall be available for transfer to the National Gallery, Trafalgar Square, when required there, if ten years have elapsed from the date of the artist's death'. The first purchases by the Courtauld Fund were impressive: Manet's *Corner of a Café-Concert*, Renoir's *At the Theatre*, Degas's *Young Spartans Exercising* and van Gogh's *Sunflowers*, *Van Gogh's Chair* and *A Wheatfield, with Cypresses*. As Courtauld intended, over time these paintings have all come to the National Gallery, some during the 1950s, and the remainder in 1961 when they were joined by later Courtauld Fund acquisitions, including masterpieces such as Monet's *The Water-Lily Pond* and Seurat's *Bathers at Asnières*.

The Gallery continues to be indebted to benefactors. A recent bequest has notably enhanced the area of the collection that Courtauld established. In 2006 the Hon. Simon Sainsbury, a long-standing friend and former Trustee, bequeathed five masterpieces: Monet's *Snow Scene at Argenteuil* and *Water-Lilies, Setting Sun*, Gauguin's *Bowl of Fruit and Tankard before a Window*, Henri Rousseau's *Portrait of Joseph Brummer* and Degas's *After the Bath, Woman drying herself* – all worthy additions to Beaumont's original gift.

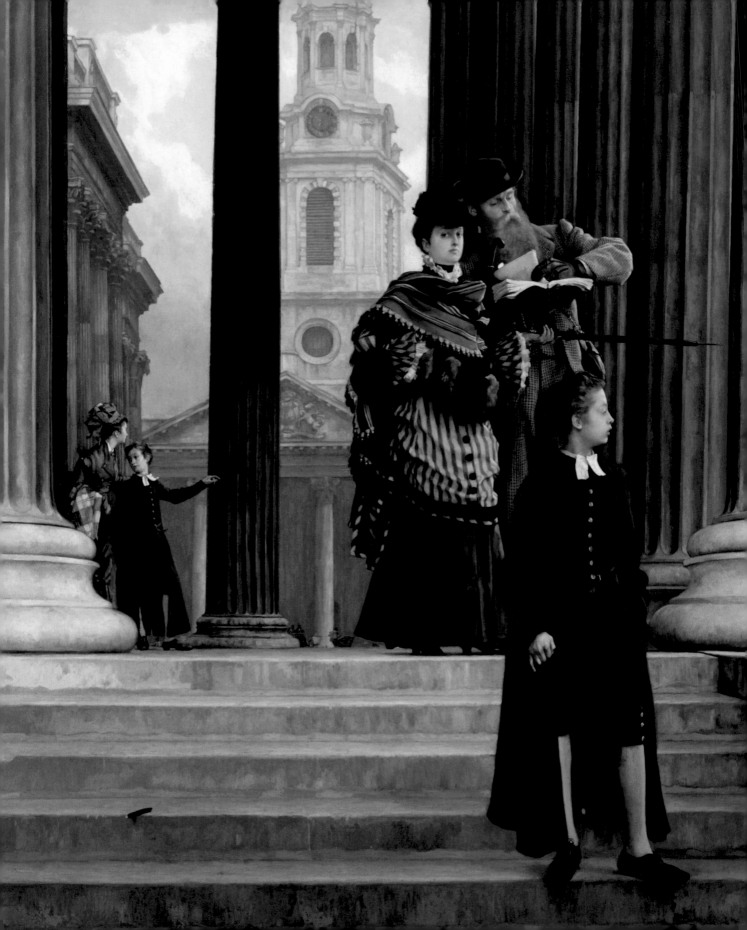

Open to All

During the nineteenth century it was a common assumption that the Gallery could be used as 'a means of moral and intellectual Improvement for the People' and its location in the centre of London was seen as an advantage for this very reason.

It was an argument advocated time and again, such as in 1870 when W.S. Allen, a Member of Parliament, stated that the working classes should be encouraged 'to frequent by thousands the British Museum and the National Gallery, instead of thronging to gin palaces, public houses, and low dancing places, and spending evenings in dissipation'. Unfortunately for Allen, the Gallery's opening times were not particularly convenient for working people, regardless of how they might prefer to spend their own time. The result of this quandary was a long-running debate on how best the Gallery might be able to reach out to the working classes of Victorian Britain.

With two days set aside for art students and the Gallery closed on Sundays, the general public enjoyed free admission to the collection on the remaining four days of the week. In order to enable more people to visit the Gallery, the logical step was to open either on a Sunday or during the evening. The issue of Sunday opening, however, was highly contentious and vigorous campaigns were launched on both sides of the argument. In 1876 the National Sunday League pressed the case for Sunday opening as a means of alleviating the 'evils of drunkenness and crime existing around us, to a large extent the result of the people having no recreation for their leisure'. On the other hand, the Lord's Day Observance Society argued that Sunday was a religious day and that the demand for Sunday opening 'is that of a small fraction of the

LEFT **James Tissot,** *London Visitors,* **1874.**

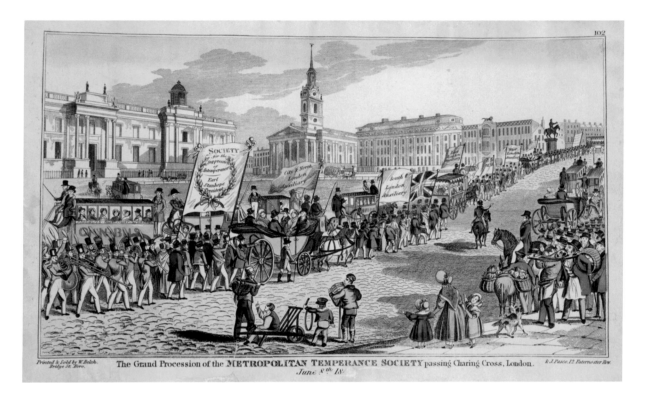

The Grand Procession of the METROPOLITAN TEMPERANCE SOCIETY passing Charing Cross, London.
June 8th 18.

population, and that it is found not among the working classes, on whose behalf it is ostensibly made, but among classes who are able to visit such places as this Institution on other days of the week'. One tactic employed by the anti-Sunday lobby was to persuade the Gallery that they could increase access to the collection just as effectively by opening in the evening. It was an argument that failed to win over the Trustees who were concerned as much by the efficacy and safety of artificial lighting (both gas and electric) as they were by the nature of the visitors they might attract at night. Despite the best efforts of the Lord's Day Observance Society, it was the National Sunday League that eventually triumphed when, on 10 March 1896, the House of Commons passed a resolution in favour

of Sunday opening. That year the Gallery introduced a trial period of Sunday opening during the summer months, extending it to all year round in 1908. Evening opening was to follow many years later, in 1935, once the concerns of the Trustees had finally been overcome and electric lighting had been installed in the Gallery.

Whereas extended opening hours encouraged more people to visit the collection, admission charges would most certainly act as a deterrent. The Gallery had been free from the day it opened but in 1880 the Trustees decided to alleviate overcrowding on the public days by allowing people to enter the Gallery on the two student days for a fee of sixpence. Having set this precedent and encouraged by the Treasury, the Gallery

Regulations for the Exhibition of the Collection of Pictures purchased for the use of the Public, from the Executors of the late Mr. Angerstein.

1st The Gallery to be open for Exhibition on Four Days in the Week, from 10 OClock in the Morning, till 5 in the Evening.

2 All Persons to be admitted gratis upon Application at the Door.

3 Not more than 200 to be admitted at the same time.

4th The Porters at the Door to inform Persons applying for admission when the Room is full.

5th Sticks and Umbrellas to be left with the Porter at the Door.

6th Artists to have admission on the other two days of the Week by Tickets, to be furnished by the Keeper of the Gallery, under the general Instructions of the Lords Commissioners of His Majesty's Treasury.

OPPOSITE A procession organised by the Metropolitan Temperance Society passing the National Gallery in about 1840. Many Victorians believed that the Gallery should be an instrument in improving people's morals, leading them away from public houses and gin palaces.

LEFT The Gallery's original regulations, issued in 1824, for the 'Exhibition of the Collection' at 100 Pall Mall.

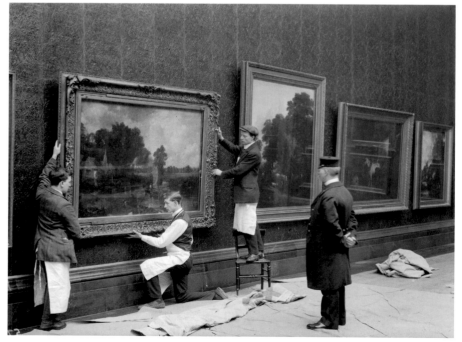

In 1924 supervision of the public passed from the Metropolitan Police to the Gallery's own attendants. As well as security, Gallery Assistants were called upon to help with a range of other duties, from fire prevention to art handling.

RIGHT Lecturer Stewart Dick gives a talk to a party of visitors to the Gallery, 1923.

BELOW A. Tyndall lectures to a group of visitors in front of Uccello's *The Battle of San Romano*, 1970.

OPPOSITE LEFT *The National Gallery News* was launched in 1978 as a means of communicating events to the public.

OPPOSITE RIGHT In 2005 the Micro Gallery was replaced by ArtStart, a new touch-screen system that incorporated the best features of its forerunner, together with new high-resolution images of the paintings and a range of added features.

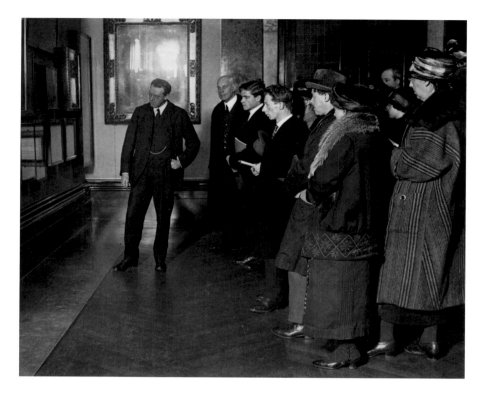

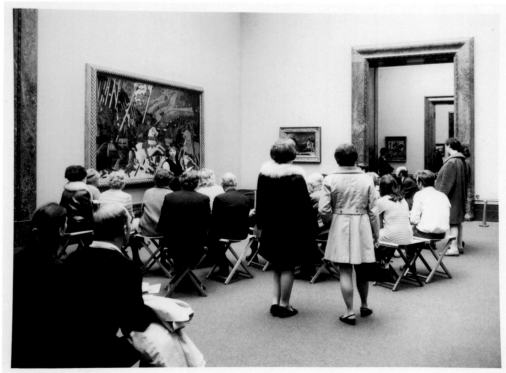

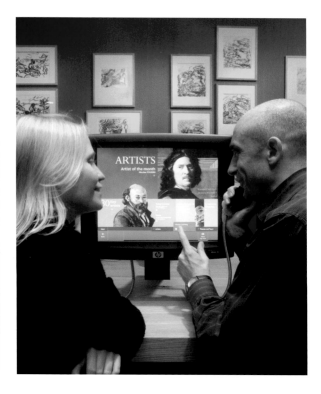

extended the number of paying days to four in 1921, which left free admission on only Wednesdays, Saturdays and Sunday afternoons. It was an attempt to generate extra revenue but the move backfired when daily average attendance on the paying days dropped to only a quarter of the numbers attending on the free days. Alarmed by the reduction in visitor numbers, the Trustees reversed their decision in 1924 and by the end of the 1930s had come to the conclusion that the admission charges on the remaining two student days were also counter-productive. When the Gallery reopened after the end of the Second World War, both the student days and the accompanying admission charges were abolished. The issue resurfaced 25 years later, when the Conservatives were elected

with a commitment to introduce entrance fees for all national museums and galleries. Despite opposition from the Trustees, admission charges were introduced in January 1974. For three months adults were charged an admission fee of 10p and children 5p. Attendance fell dramatically to 31,746 in March 1974 from 115,700 in the same month a year previously. These charges were to be short-lived, as the following month the Conservatives fell from office and the new Labour Government abolished charging at the end of March. Entrance to the collection has remained free ever since.

One item that visitors would have paid for in 1824 was the guide to the collection, a simple catalogue that was seven pages long and cost sixpence. It was the Gallery's

TOP LEFT Children receiving question sheets for the Mad Hats Quiz, devised by the Education Department, in 1978.

BOTTOM LEFT The Mad Hats Quiz was judged by Sir Michael Levey, the Gallery's Director.

RIGHT James Heard of the Education Department demonstrating to schoolchildren in 1981 how Gainsborough might have painted *The Morning Walk*.

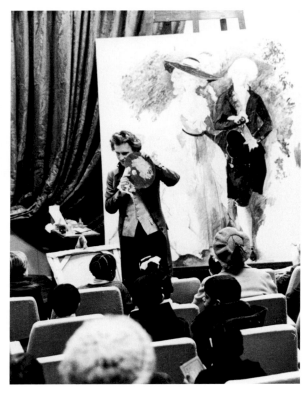

first publication and aimed to enhance visitors' understanding of the paintings. Throughout the nineteenth century and the first decades of the twentieth the catalogues became ever more detailed. However, a new standard in scholarship was set when the evacuation of the collection to Wales during the Second World War enabled the Assistant Keeper, Martin Davies, to study the paintings without the distraction of other duties and to embark on a series of scholarly catalogues on individual schools of art. These continue to be enhanced by the Gallery today and have

been joined by numerous other guides across a range of media. The first audio guides were made available in 1968, and 3,300 tours, each costing 2s/6d, were taken up in the first nine months of operation. The Gallery's website first went live in 1998 and two years later offered internet users a complete catalogue of the collection. One of the most innovative tools when it was launched in 1991 (and subsequently superseded by ArtStart) was the Micro Gallery. This was an example of how new technology could offer visitors an alternative way to experience the collection.

A world first, the Micro Gallery housed 12 purpose-built computer units, each containing an electronic catalogue of the paintings. The public could use the touch-screen terminals to find out more information about favourite paintings or to plan a visit and print out a personal tour of the Gallery. An instant success, one of the first visitors commented that it was a 'great use of technology and interlinking of screens; the trouble is you spend so much time in here that you forget the actual gallery'.

Advances in technology have moved forwards, together with more traditional methods of interpreting the collection. The introduction of public lectures in 1914 heralded the start of educational activities, which would ultimately lead to the establishment of an Education Department in 1974 and an expanded range of programmes for adults, families, teachers and schoolchildren. A year later the Gallery opened its first dedicated space for temporary exhibitions in the North Galleries and celebrated with the exhibition *The Rival of Nature*, a fresh look at Renaissance painting that drew some 350,000 visitors over four months. Since then, new

THIS PAGE The National Gallery's café in 1980. A restaurant was first opened in the Gallery in 1947 and, after several moves and refurbishments, is now complemented by a café and espresso bar.

OPPOSITE The Sainsbury Wing shop, one of the Gallery's three retail outlets, following refurbishment in 2009.

PAGES 62–3 A selection of postcards, from about 1900 to 1958, of the National Gallery and Trafalgar Square.

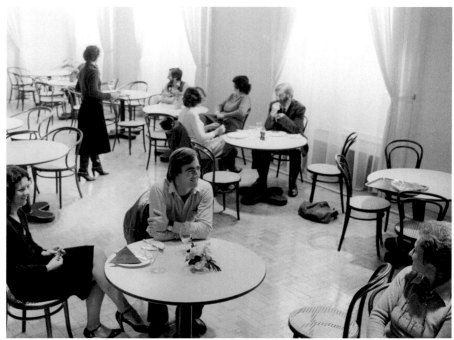

temporary exhibition spaces have opened in the Sunley Room, the Sainsbury Wing and Room 1, all of which have enabled the Gallery to offer a variety of exhibitions that display the paintings in a new context or give them a particular focus.

As well as initiatives in interpreting the paintings, visitor facilities have also been developed to meet public demand. Initially even the most basic of amenities were overlooked, such as public lavatories, which were not installed until 1887. There was no restaurant and visitors would bring their own refreshments. In 1850 the Keeper Thomas Uwins observed one such group 'who had a basket of provisions, and who drew their chairs round and sat down, and seemed to make themselves very comfortable; they had meat and drink; and when I suggested to them the impropriety of such a proceeding in such a place, they were good-humoured, and a lady offered me a glass of gin'. Despite such incidents, the Gallery believed that its central location dispensed with the need for any form of in-house restaurant and even as late

as 1934 a proposal to offer light refreshments failed to come to fruition. It was only when a temporary canteen was established in the Gallery during the Second World War that its popularity spurred the Trustees into action. After the war the Gallery lost little time in establishing a new restaurant, which opened in January 1947 to much acclaim. In contrast, there had been a more mixed response when the Gallery's first shop, a stall selling publications and postcards, had opened in 1915, as the Director Charles Holmes recorded: 'A few diehards might sneer at the gay Catalogue Stall as degrading the Gallery to the level of a shop, but the public interest which it evoked, quite apart from the profits, was enough to console us.' It is unlikely that the 'diehards' would be impressed with the three shops and three catering outlets available today, but they might acknowledge that they have become an integral part of the Gallery. As times have changed, the Gallery has come to recognise that the shop and the café also have their own roles to play in enhancing a visit to the collection.

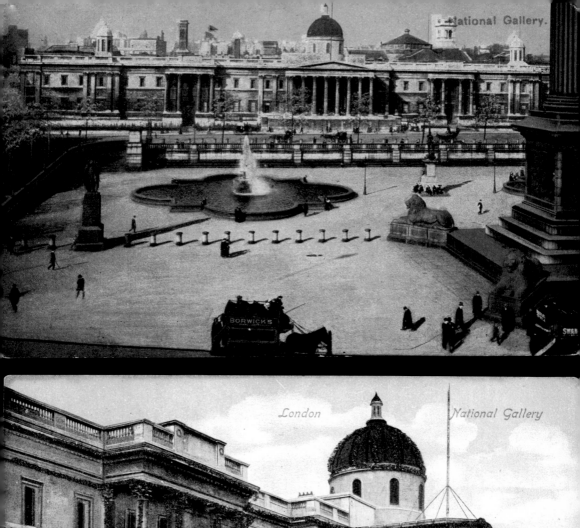

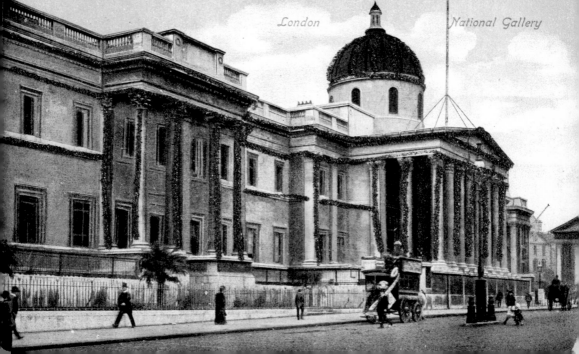

London National Gallery

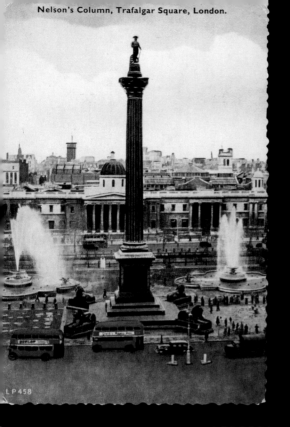

Nelson's Column, Trafalgar Square, London.

LP458

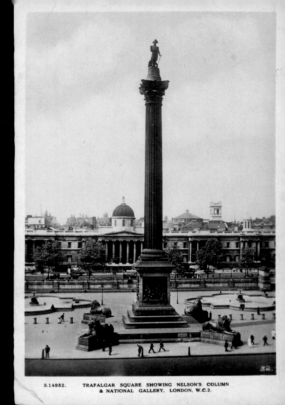

S.14952. TRAFALGAR SQUARE SHOWING NELSON'S COLUMN
& NATIONAL GALLERY, LONDON, W.C.2.

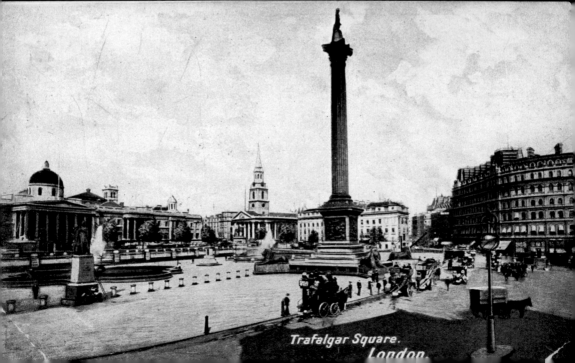

Trafalgar Square.
London.

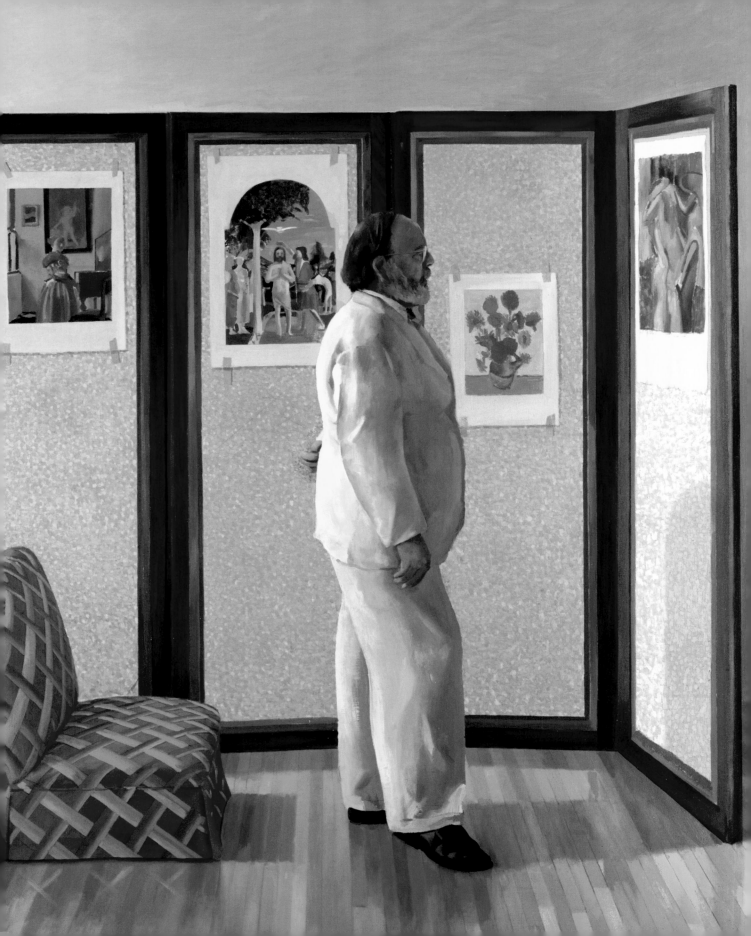

Inspiring Art

Practising artists have always held a central position in the history of the Gallery, with the inclusion of modern British painting considered to be of the utmost importance right from its start. The nineteenth-century Directors were all painters at a time when contemporary art formed part of the Collection, including paintings by Eastlake. Students and professionals alike have long been encouraged to spend time studying the techniques of the Old Masters and artists continue to be welcomed into the Gallery, drawing inspiration from the paintings and, in the works they create, offering the public new ways of experiencing old favourites.

The original regulations of the Gallery specified that two days per week were to be set aside specifically for art students to study and copy the paintings. Known as 'copyists', the numbers of these students increased throughout the nineteenth century as copying became ever more popular. By 1880 more than 200 copyists were visiting the Gallery on each of the student days. Although the range of paintings copied was wide, the three most popular pictures that year were all works that appealed very much to Victorian sensibilities: Sir Edwin Landseer's *King Charles Spaniels*, *A Girl* by a follower of Greuze and Murillo's *A Peasant Boy leaning on a Sill*. The copyists not only included serious art students but also professional artists who were meeting an increased demand for copies from dealers. There was also a small number for whom it was simply a fashionable pastime. As one observer remarked, these were the 'dilettante ladies and gentlemen, who drive up in broughams and hansoms, and who enjoy playing at artist life, having none of its cares'.

LEFT David Hockney, *Looking at Pictures on a Screen*, 1977 (detail).

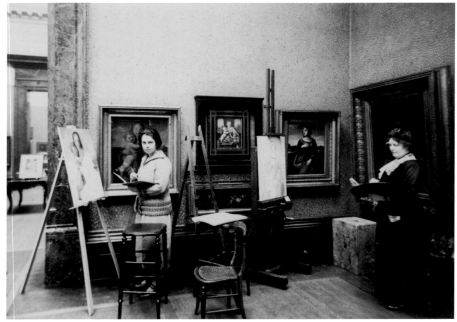

During the twentieth century the number of copyists started to fall and separate student days were abolished in 1945. The scheme, however, remains in operation and today's artists at their easels are still inspired by the paintings.

It is not only the art inside the building that has proved inspirational. The Russian artist Boris Anrep recounted that it was 'the sight of pavement artists outside the National Gallery' that encouraged him to approach the Trustees in 1926 with an idea to place decorative mosaic pavements in the entrance vestibule. The Gallery welcomed the proposal and between 1928 and 1929 Anrep laid two mosaic pavements in the west and east vestibules, illustrating *The Labours of Life* and *The Pleasures of Life* respectively. They were joined in 1933 on the central landing by a third pavement depicting *The Awakening of the Muses*. All the

work was funded by private donations, as was a fourth and final mosaic, which Anrep laid in the north vestibule in 1952 and titled *The Modern Virtues*. In addition to his artistic skills, Anrep had a playful side and incorporated many a famous face into his mosaics. On the central landing Virginia Woolf is transformed into Clio, the Muse of History, and Greta Garbo becomes Melpomene, the Muse of Tragedy; while in the north vestibule Delectation is represented by Margot Fonteyn and Leisure by T.S. Eliot. A political dimension to the mosaics is seen in the depiction of Winston Churchill as Defiance, where a resolute Churchill wards off a swastika-shaped monster away from the white cliffs of Dover.

It was to be another 25 years before the Gallery once again engaged with a contemporary artist on such a level. In 1976 conversations between the Director Michael

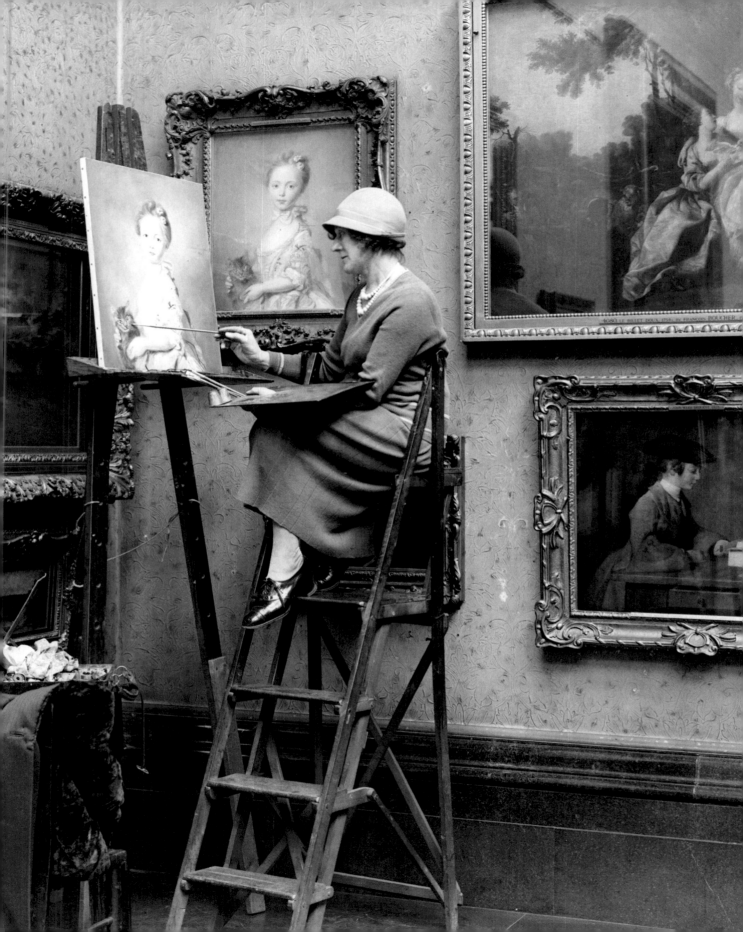

TOP Boris Anrep (1883–1969) at work on his mosaic pavement *The Awakening of the Muses* on the central landing in 1933. Born in St Petersburg, Russia, Anrep moved in 1908 to Paris and in 1910 to Edinburgh, where he studied drawing. From 1911 Anrep divided his time between Paris and London, and, after serving in the Imperial Russian Guard between 1914 and 1916, he returned to London in 1917 as Military Secretary to the Russian Government Committee. Continuing to move between Paris and London for the rest of his life, he died in London in 1969.

BOTTOM AND OPPOSITE Greta Garbo, Winston Churchill and Virginia Woolf make an appearance in Boris Anrep's mosaic pavements.

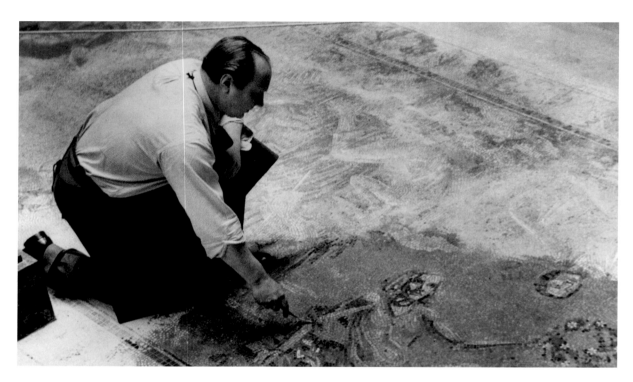

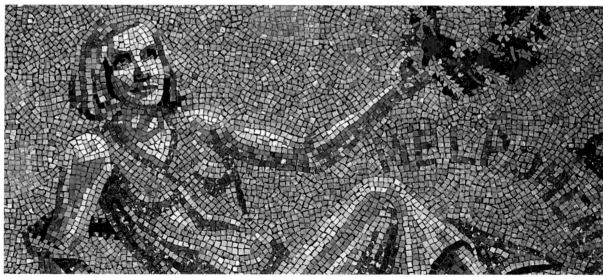

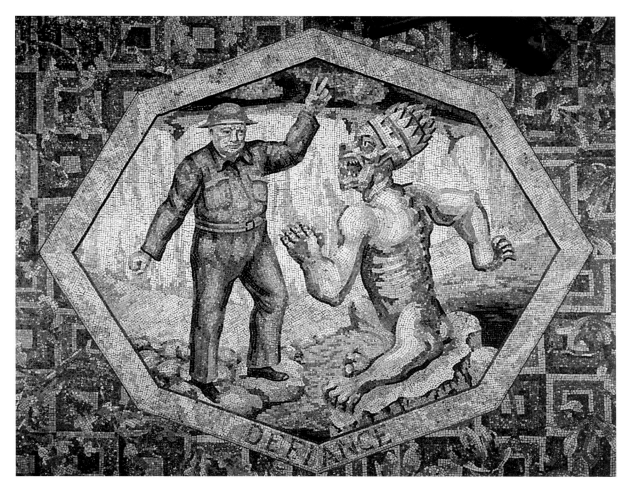

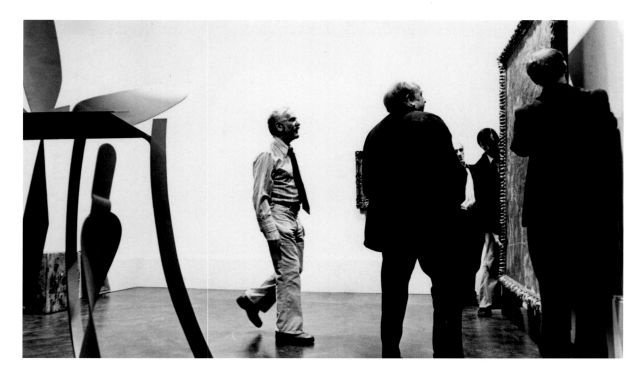

ABOVE Anthony Caro at the hanging of *The Artist's Eye* exhibition in 1977.

RIGHT *The Artist's Eye*, 1981, curated by David Hockney, showing Henry Geldzahler re-creating his pose in the painting *Looking at Pictures on a Screen*. Hockney and Geldzahler are joined for the event by the Director Michael Levey and artist Howard Hodgkin.

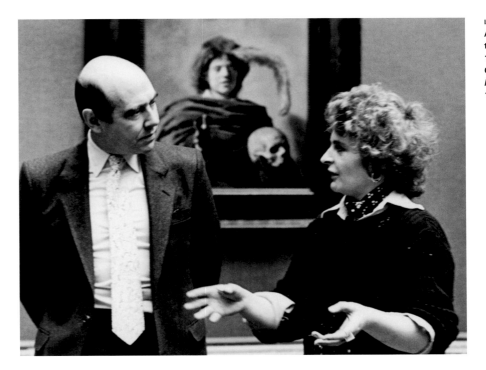

Levey and the sculptor Anthony Caro led the Gallery in a new direction in relation to contemporary art. As a result Caro was invited the following year to curate the first of a new series of annual exhibitions called *The Artist's Eye*, in which the artist selected a number of paintings from the collection to display alongside one of his own works of art. Five artists in total took part and the series came to an end in 1981 with David Hockney, who had the ideal painting to exhibit. His *Looking at Pictures on a Screen* depicts his friend Henry Geldzahler looking at reproductions of National Gallery paintings taped onto a screen. Hockney's painting was exhibited along with the four Gallery pictures featured within it: Vermeer's *A Young Woman standing at a Virginal*, Piero della Francesca's *The Baptism of Christ*, van Gogh's *Sunflowers* and Degas's *After the Bath, Woman drying herself*. The exhibition was made all the more interesting by the fact that Hockney still had the props that he used for his painting and could therefore re-create the original scene as part of the display. This allowed visitors to step into the picture and take Geldzahler's place. Hockney hoped that the experience would intensify one of his original intentions in painting Geldzahler – for participants to 'identify with him and his pleasure, because you were doing exactly the same, looking at it'.

The success of *The Artist's Eye* not only led to its revival in 1985 but also encouraged a new development in the Gallery's relationship with contemporary art. In 1980, supported by the Arts Council, the Gallery launched the Artist-in-Residence scheme with Maggi Hambling as its first occupant. The scheme

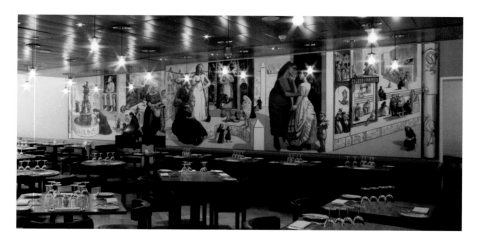

offered practising artists the chance to interact both with the collection and the public. Provided with a studio in the Gallery, the artists held regular open days and, at the end of their residency, were given the opportunity to put on an exhibition of the works they had created. A total of nine artists served as Artist-in-Residence until in 1989 the Gallery amended the scheme and created a new position of Associate Artist. Although similar to the previous scheme, artists appointed to the new residency were invited to create works that were directly related to the Gallery's paintings. Paula Rego was appointed the first Associate Artist in 1990 and in her exhibition the following year she displayed paintings inspired by a range of pictures in the collection, from Philippe de Champaigne's *The Dream of Saint Joseph* to Antonello's *Saint Jerome in his Study*. One lasting legacy of Rego's residency is the commission she received to decorate the Sainsbury Wing restaurant, where her mural paintings, *Crivelli's Garden*, form a magnificent backdrop to the room. Since then six more artists, from Ken Kiff to Alison Watt, have followed in Rego's footsteps as Associate Artist, each taking up the challenge to create new works inspired by the collection.

The Gallery continues to explore new ways in which it can encourage a dialogue between the collection and contemporary art. In the exhibition *Encounters: New Art from Old* in 2000, the Gallery invited '24 great artists of our time to converse with the greatest artists of all time'. Each artist took a painting in the Gallery's collection as their inspiration to create a new work of art: for example, Cy Twombly chose Turner's *The Fighting Temeraire* while Frank Auerbach opted for Constable's *The Hay Wain*. Other artists have had similar solo shows, such as Anthony Caro's *Sculpture from Painting* in 1998 and Bill Viola's *The Passions* in 2003; while in 2005 Tom Hunter's exhibition *Living in Hell and Other Stories* broke new ground as the Gallery's first display of photographs based on Old Master paintings. Together with the collection itself, these exhibitions are all part of the continuing story of art.

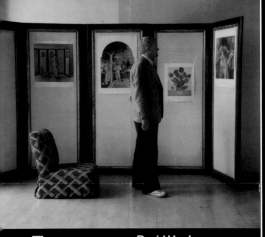

The artist's eye

Admission free

David Hockney
Looking at Pictures on a Screen
at the
National Gallery
1 July-31 August 1981

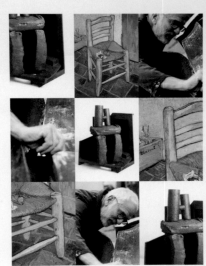

CARO at the National Gallery

SCULPTURE FROM PAINTING

25 February – 4 May 1998

Admission free

THE
**NATIONAL
GALLERY**

Monday to Saturday 10am-6pm, Wednesday until 8pm, Sunday 12noon-6pm
(Closed Good Friday, 10 April)
Trafalgar Square, London WC2 • Information 0171-747 2885

Supported by The Bernard Sunley Charitable Foundation and The Henry Moore Foundation

ENCOUNTERS

NEW ART FROM OLD

AUERBACH*CONSTABLE*
BALTHUS*POUSSIN*
BOURGEOIS*TURNER*
CARO*DUCCIO*
CAULFIELD*ZURBARAN*
CLEMENTE*TITIAN*
COX*PIERO DELLA FRANCESCA*
FINLAY*CLAUDE*
FREUD*CHARDIN*
HAMILTON*SAENREDAM*
HOCKNEY*INGRES*
HODGKIN*SEURAT*
JOHNS*MANET*
KIEFER*TINTORETTO*
KITAJ*VAN GOGH*
KOSSOFF*RUBENS*
LE BRUN*RAPHAEL*
OLDENBURG+VAN
BRUGGEN*VERMEER*
REGO*HOGARTH*
TAPIES*REMBRANDT*
TWOMBLY*TURNER*
UGLOW*MONET*
VIOLA*BOSCH*
WALL*STUBBS*

NATIONAL GALLERY
TRAFALGAR SQUARE, LONDON

14 June - 17 September 2000

Admission (includes audioguide) £7 Concessions: £5 Students: £3
Advance booking: First Call 0870 906 3891 (handling charges)
Information and tickets: www.nationalgallery.org.uk

Sponsored by
MORGAN STANLEY DEAN WITTER

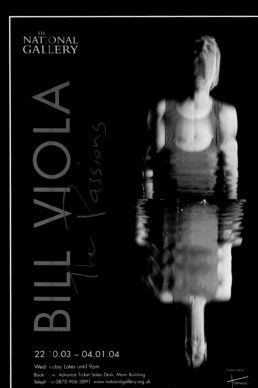

THE
**NATIONAL
GALLERY**

BILL VIOLA *The Passions*

22.10.03 – 04.01.04

Wed - Friday Lates until 9pm

Book now: Advance Ticket Sales Desk, Main Building
Telephone 0870 906 3891 • www.nationalgallery.org.uk

Produced by
Genesis

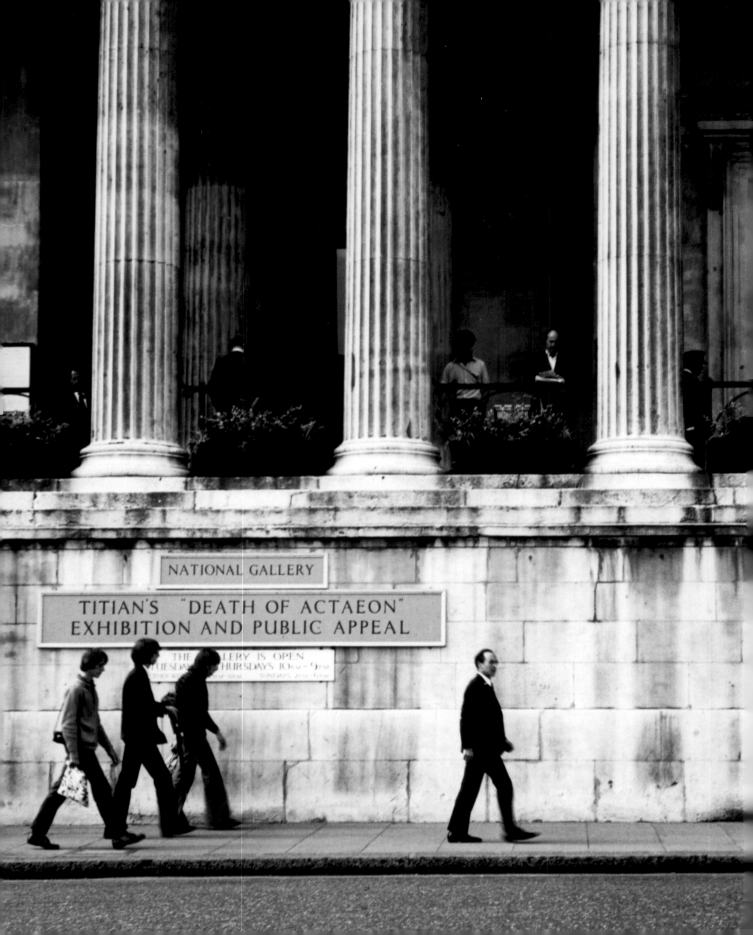

Paramount Pictures

As the nineteenth century drew to a close, the Gallery found itself facing ever-increasing competition to secure great works of art for the nation. The entry of wealthy Americans into the art market together with the energetic acquisition policy of the German Empire's national gallery in Berlin pushed up prices just at a time when the introduction of inheritance tax was prompting many British collectors to consider selling their masterpieces. To meet this challenge the Gallery turned not just to the Treasury but also to the nation at large, and the notion of the public appeal was born.

Appeals were not entirely a twentieth-century phenomenon. Constable's *Cornfield* was presented to the Gallery in 1837 by a number of the artist's friends who had subscribed to a fund to buy the painting as a tribute to the recently deceased artist. But such instances were essentially private and by invitation. The first major acquisition made possible by the support of wealthy private individuals was that of a group of three pictures including Holbein's *The Ambassadors* in 1890. However, it was not until the founding of the National Art-Collections Fund in 1903 that the truly public appeal came into its own. The NACF was established as an independent charity to help museums and galleries acquire works of art that they would otherwise be unable to afford. One of its earliest acquisitions for the National Gallery was Velázquez's *The Rokeby Venus*, purchased in 1906 for the then huge sum of £45,000. It was a tremendous achievement but one that would soon be dwarfed by an even greater challenge.

LEFT Members of the public stroll past a banner on the Gallery's portico promoting the campaign to acquire Titian's *Death of Actaeon* in 1972.

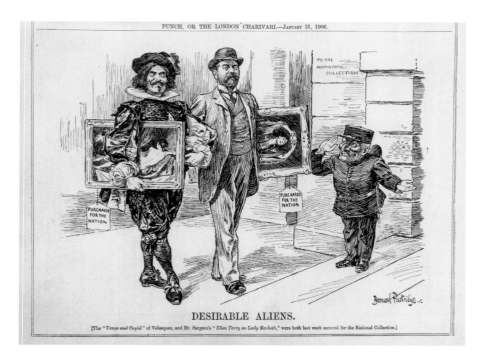

PUNCH, OR THE LONDON CHARIVARI—January 31, 1906.

DESIRABLE ALIENS.

[The "*Venus and Cupid*" of Velasquez, and Mr. Sargent's "*Ellen Terry as Lady Macbeth*," were both last week secured for the National Collection.]

Holbein's *Christina of Denmark, Duchess of Milan* had been on loan to the Gallery for so many years that many people considered it to be part of the fabric of the collection. But in 1909 its owner, the Duke of Norfolk, decided to put the painting up for sale. Its price was £72,000. The NACF launched a major press campaign and attracted a wealth of private donations, while the Chancellor of the day, David Lloyd George, offered Government support to the tune of £10,000. Despite such measures, the NACF remained £40,000 short of its target on the day when its option to acquire the painting was due to expire. All seemed lost and it looked as though the Holbein would soon be on its way to a new home in the USA where, it was believed, the industrialist and art collector Henry Clay Frick was interested in acquiring the painting. But on that day, 1 June 1909, a member of the NACF's Executive Committee, Isidore Spielmann, received a letter from an unknown lady who offered to make up the shortfall. Spielmann dashed off the following telegram at 2.45 p.m: 'Option expires tonight. £40,000 would secure picture. All depends on you. Please reply immediately.' The reply duly came from the mysterious stranger: 'I will make up deficiency for the Holbein.' Spielmann was both amazed and delighted. The very next day he visited Colnaghi's, the art dealers handling the sale, to inform them that the NACF would be exercising its option to buy the painting. The dealer at Colnaghi's was so incredulous that the NACF had actually raised the money that he had to be whisked round by cab to the donor's bank manager to hear for himself that the offer was genuine. The dealer was left almost speechless: 'This is the most remarkable transaction I have ever been connected with.'

May 4th 1905

Board of Trade,
Whitehall Gardens
S W

Dear Sir Charles Holroyd.

My chief Winston Churchill seems disposed to take an interest in the Holbein & I think he would be inclined to make an effort if he were properly briefed. Would you think it worth while to let me have a short letter which I could show him, making the strongest possible case for keeping the picture? I am sure I need not apologise for troubling you in such a good cause.

Yours sincerely

E Marsh

BELOW Fears about a drain of works of art to the USA prompted the establishment of the National Art-Collections Fund in 1903. Bernard Partridge's *Punch* cartoon of 1909 expresses the very real concern that Holbein's *Christina of Denmark* would join the exodus. However, at the last minute an anonymous donor saved the painting for the nation.

OPPOSITE Hans Holbein the Younger, *Christina of Denmark, Duchess of Milan*, 1538.

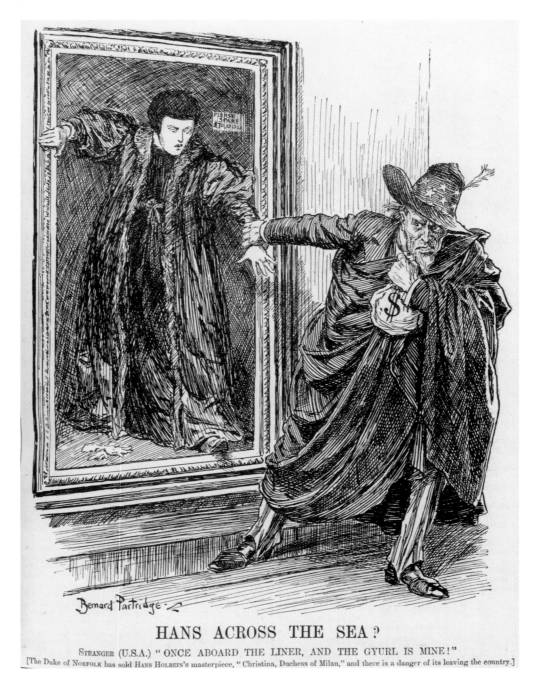

HANS ACROSS THE SEA?

STRANGER (U.S.A.) "ONCE ABOARD THE LINER, AND THE GYURL IS MINE!"

[The Duke of NORFOLK has sold HANS HOLBEIN's masterpiece, "Christina, Duchess of Milan," and there is a danger of its leaving the country.]

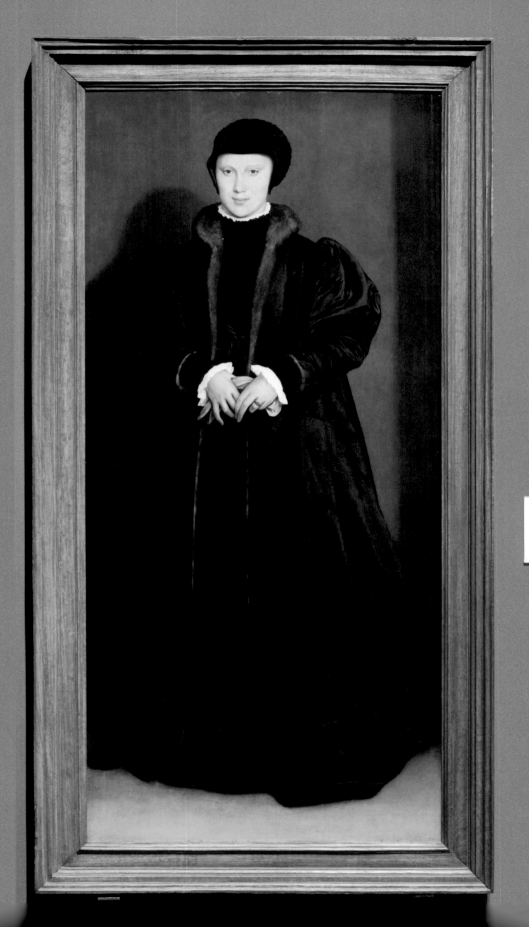

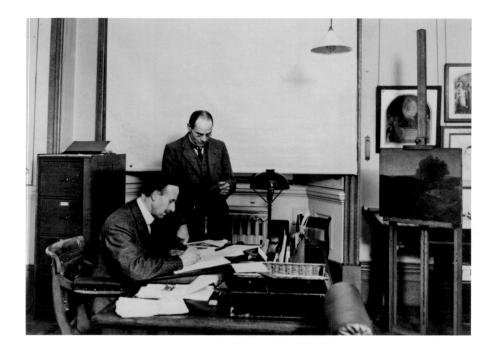

It was remarkable indeed. At the eleventh hour the Holbein had been saved for the nation by the generosity of an anonymous donor. But who was she? She had instructed the NACF to keep her name completely private. And to this day the NACF (now known as The Art Fund) has honoured her wishes. Her identity remains a mystery, recorded only in a sealed envelope, which is passed down to each new chairperson of The Art Fund, never to be opened.

The advent of the First World War understandably saw the Government suspend acquisitions funding. There was, however, one very important exception. The sale of artworks from the collection of the artist Edgar Degas in 1918 presented the Gallery with a unique opportunity to fill a number of gaps in the collection. The problem was that the Government could not be seen to sanction expenditure on paintings at a time when so

many people in the country were suffering privations after four long years of war. The solution was proposed by John Maynard Keynes, an up-and-coming Treasury official, who suggested that the Gallery be granted up to £20,000, which could be paid for from existing war loans to the French government. Treasury approval was forthcoming and the Director, Charles Holmes, was authorised to travel to Paris for the first Degas sale on 26 and 27 March 1918. On the way Holmes observed destroyers in the English Channel, airships in the sky and the sounds of battle near Amiens. He arrived in a Paris crowded with refugees and under bombardment from the German guns, the Big Berthas. The next day at the sale, the auction house reverberated with the explosion of artillery shells pounding the French capital from many miles away. Holmes kept his nerve and bid

successfully for 27 paintings and drawings at the sale, including Ingres's *Monsieur de Norvins,* Manet's *The Execution of Maximilian* and Delacroix's *Louis-Auguste Schwiter* – all for a little under £12,000. It was the return journey across the Channel that really tested Holmes: 'Though it was a roughish crossing, I never felt one touch of sea-sickness, being much too anxious lest a German mine or torpedo should catch us at the last minute, and send all my precious purchases to the bottom.' Safely back in London, Holmes deposited the smaller artworks in the Gallery and had to enlist the assistance of four station porters, a handcart and two lanterns to help him carry the two largest paintings – the Manet and the Delacroix – back to Trafalgar Square. There they joined the national collection, a testimony both to Holmes's determination and the Government's crucial financial support.

The last-minute rescue of the Holbein and the *ad hoc* nature of the funding for the purchases from the Degas sale only emphasised the fragile state of the Gallery's position with regard to acquisitions. By the 1920s the Trustees of the Gallery, and notably Sir Philip Sassoon, felt that a more proactive approach was required. On 6 July 1922, Lord Lansdowne, Chairman of the Board of Trustees, wrote to the Treasury seeking assurances that the Government would come to the Gallery's assistance to purchase a number of internationally important pictures should they come onto the open market. These works would be described in a short secret list of 'paramount pictures' that the Government would undertake to buy if they ever became available. In October 1922 Holmes submitted an initial Paramount List to the Treasury, which comprised the

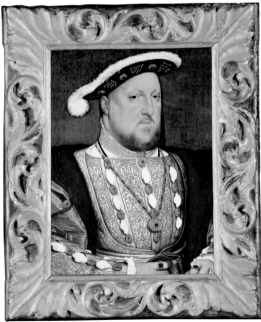

ABOVE *The Wilton Diptych* (about 1395–9) appeared on the Gallery's original list of 'paramount pictures' in 1922. It was acquired in 1929 from the Earl of Pembroke.

RIGHT Holbein's *Portrait of King Henry VIII* (about 1534–6), which was included in the Paramount List, was sold abroad in 1934 and is now in the Thyssen-Bornemisza Collection in Madrid.

following paintings: Titian's *Diana and Actaeon*, *The Three Ages of Man*, *The Vendramin Family* and *Portrait of a Young Man*; Holbein's *Portrait of King Henry VIII*; Memling's *The Donne Triptych*; and *The Wilton Diptych*.

The Chancellor agreed to provide additional funding 'in the event of pictures on the list submitted to him being in danger of sale outside this country'. Despite such assurances, the Gallery feared for the worst when both *The Wilton Diptych* and Titian's *The Vendramin Family* came on the market in 1929 at a total cost of £212,000. Fortunately, the existence of the Paramount List helped persuade the Government to provide half the purchase price for both works; the remainder was raised from private donations and the NACF. But these successes were matched with disappointments too. The sale and export of Holbein's *Portrait of King Henry VIII* to Baron Thyssen in 1934 could not be prevented and its loss to the nation was keenly felt (the painting now forms one of the highlights of the Thyssen-Bornemisza Collection in Madrid). Of the remaining works on the original list, *The Donne Triptych* was acquired by the Gallery in 1957 and *Diana and Actaeon* was purchased jointly by the Gallery and the National Galleries of Scotland in 2009; *The Three Ages of Man* and the *Portrait of a Young Man* remain in private collections in the United Kingdom, the former on loan to the National Galleries of Scotland and the latter to the National Gallery itself.

The Paramount List was revised a number of times in the decade following its inception but by the mid 1930s it had fallen into abeyance. Its final death knell came in December 1953 when the Gallery sought Government support for the acquisition of Gainsborough's *Morning Walk* (the painting had made it onto a revised Paramount List in 1927). While the Treasury was prepared to make a one-off contribution of £10,000 towards the painting, they added that the Paramount List 'was compiled under conditions very different from those today'. The Gallery was back at square one. Or was it? The post-war period had seen a number of initiatives made in the Gallery's favour. The Government had taken an important step to retain works of art in the United Kingdom when it introduced export controls as a wartime measure in 1939. These controls were explicitly applied to heritage items in 1944 and continued after the end of the war. In the following decade the Government passed the Finance Act in 1956, which made it possible for works of

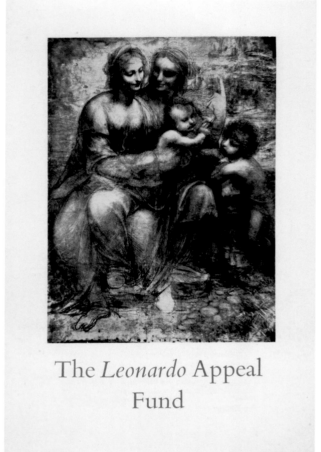

art to be accepted by the Inland Revenue in lieu of inheritance tax – a scheme that has since enabled many exceptional paintings to be acquired by the Gallery. And while the Government no longer wished to be bound by the Paramount List, it continued to consider special grants based on individual merit and actually increased the annual purchase grant from £12,500 per annum in 1955 to £125,000 in 1960 and to £480,000 in 1970. But even measures such as these would not be enough when a major masterpiece came onto the market.

In March 1962 the Royal Academy announced that it had decided to sell its famous Leonardo Cartoon. The price was £800,000. The Gallery's Director, Philip Hendy, heard of the news while in Madrid where he had been pursuing the acquisition of Rubens's *Portrait of the Duke of Lerma*. Ironically, a public outcry in Spain against the sale of the Rubens abroad resulted in its eventual acquisition by the Prado. Similar demands started to be heard in the United Kingdom regarding the Leonardo Cartoon and the Royal Academy agreed to postpone

BELOW **Preparing the Leonardo Cartoon for display in the Central Hall in 1962. The appeal had an enormous** effect, resulting in almost 10,000 people queuing to see the Cartoon on the first day alone.

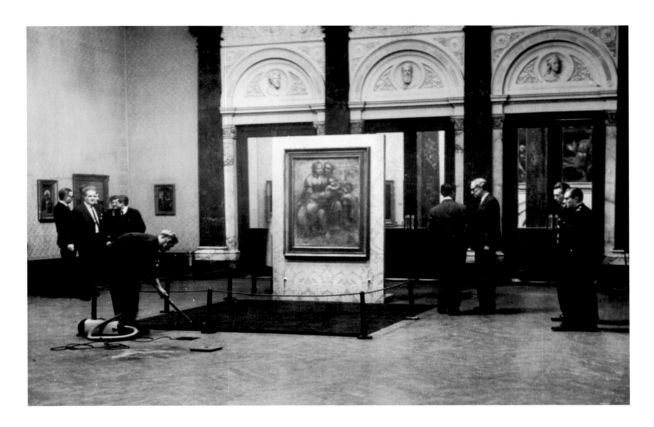

the sale of the work to give the nation the opportunity of buying it. Once again the NACF stepped into the breach and its Chairman, Lord Crawford, launched a public appeal with a deadline set for the end of July. The Cartoon was put on display at the Gallery on 31 March and became something of a celebrity. On the first day alone almost 10,000 people queued to see it, although Lord Crawford bemoaned the fact that only £665 was raised in donations compared to the estimated £10 million spent betting on the Grand National the very same day. Over

the next four months donations were received in museums and galleries across the country; fund-raising dinners and events were held; and the Queen visited the Gallery to lend the appeal her support. At one point it was even considered that images of the Cartoon could be placed on cigarette packets, with sixpence from the sale of each packet contributing to the fund. Despite such enthusiasm, the appeal made slow progress. The proposed purchase of the Cartoon also failed to attract universal support, with some people voicing concerns about its cost.

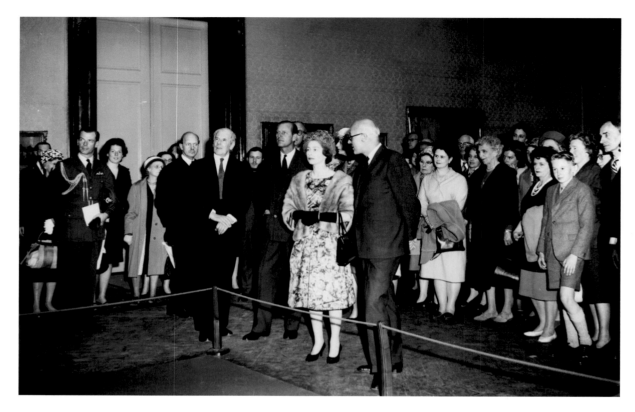

ABOVE Queen Elizabeth II visiting the Leonardo Cartoon display in May 1962 to bolster support for the appeal.

RIGHT After its acquisition, the Leonardo Cartoon was examined in the Conservation Department by the Chief Restorer Arthur Lucas (right) and the Keeper Martin Davies (left).

OPPOSITE Leonardo da Vinci, *The Virgin and Child with Saint Anne and Saint John the Baptist*, known as The Leonardo Cartoon about 1499–1500.

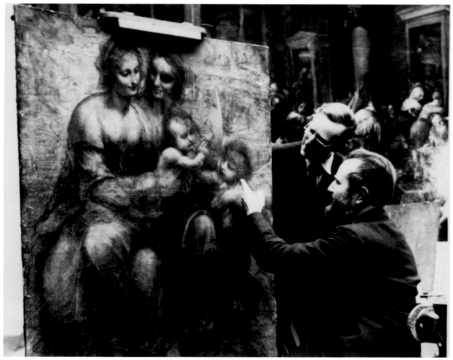

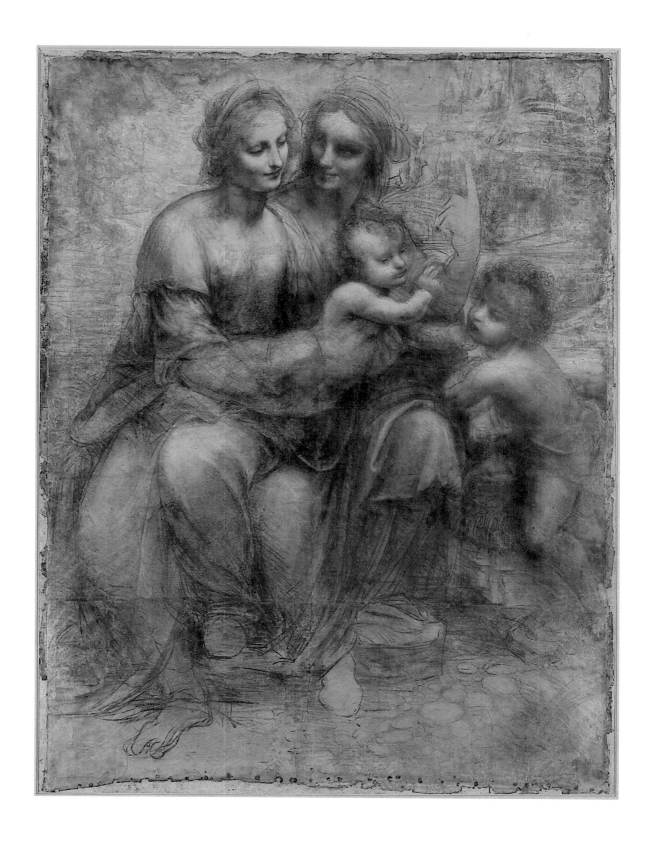

By mid July many commentators were starting to predict failure and the NACF reached its self-imposed deadline of 31 July with only a little more than £400,000 raised. Although this was an impressive figure, it constituted only half the total amount required and the campaign appeared doomed to failure. Then, as with the Holbein over 50 years earlier, a saviour appeared at the last minute, this time in the guise of the Prime Minister, Harold Macmillan. On 31 July Macmillan announced to the House of Commons that the Government would contribute a special grant of £350,000 towards the appeal fund. The NACF immediately guaranteed the remaining balance and the Leonardo Cartoon was saved. The following morning the *Daily Mirror* proclaimed the news: 'Leonardo is safe – Mac forks out.'

An even greater target was set when the J. Paul Getty Museum acquired Titian's *The Death of Actaeon* in June 1971. Before the painting could be shipped to California, the Government agreed to place an export stop on the work for one year. During this time the Gallery would need to raise enough money to match the £1,763,000 already paid by the Getty. Confidence at the Gallery was low following the loss earlier that year of Velázquez's *Juan de Pareja* to the Metropolitan Museum of Art in New York. The Trustees knew that any campaign to save the Titian would be destined to fail unless they could secure an early indication of Government support. They took the bold step of pledging £1 million from the Gallery's current and future purchase grants. In response, the Government promised to match any public donations pound for pound. This move enabled the Trustees to launch the Gallery's first ever, public appeal on 1 December 1971 (previous appeals having been managed by the NACF). The NACF and Pilgrim Trust pledged £100,000 and £50,000, leaving the Trustees £231,500 to raise (these sums taken together would then be matched by the Government). Their strategy focused on a high-profile media campaign that included a letter to *The Times* signed by several public figures, including the artists Francis Bacon, Ben Nicholson and Graham Sutherland. Bacon also promoted the campaign on radio while Dame Flora Robson did likewise on television. Benjamin Britten lent his support by giving a concert at the Gallery in aid of the appeal. The donations flowed in: from

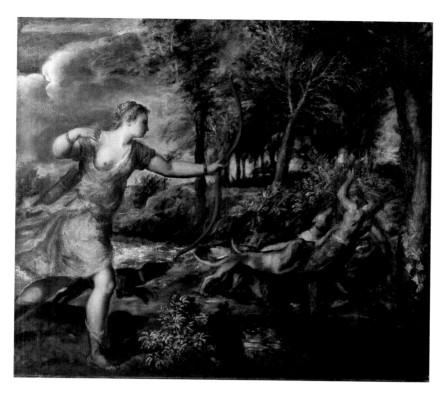

LEFT Titian, *The Death of Actaeon*, 1559–75.

BOTTOM LEFT In December 1971 the Gallery launched a high-profile public appeal to save Titian's *The Death of Actaeon*. By July 1972 they had raised the £1,763,000 required to secure the painting.

BOTTOM RIGHT A concert in aid of the Titian Appeal was given in the Gallery in 1972. This was the first time such an event had been staged since the pianist Myra Hess had enthralled audiences during the Second World War. Staged in the Barry Rooms once more, it featured Benjamin Britten, who had also performed during the war. Tickets cost £5 and included refreshments.

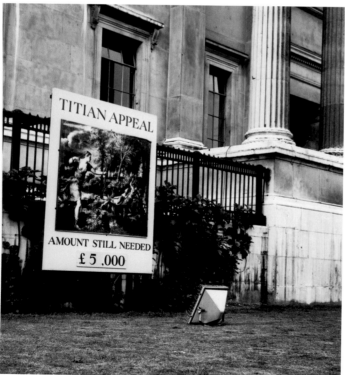

TITIAN APPEAL CONCERT

"The Death of Actaeon" (Detail: Diana) Titian

8.15 p.m.
SUNDAY 28th MAY 1972
in the
NATIONAL GALLERY

SEAT **M** 1

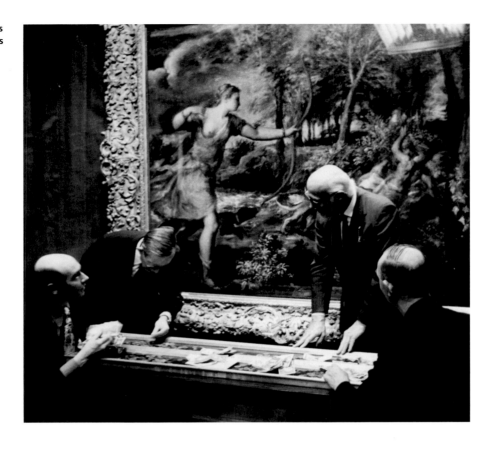

a few pence dropped into a collecting box to a single anonymous gift of £75,000. The strategy was a success. It soon became clear that this campaign would not repeat the slow progress of the Leonardo Appeal and on 6 July 1972 a cheque for the sum of £1,763,000 secured the painting for the nation.

Many more paintings have since been acquired for the Gallery thanks in part to the goodwill and generosity of charities, friends and supporters. One exceptionally good friend to the Gallery was J. Paul Getty Jnr. His establishment in 1985 of an endowment fund totalling £50 million has resulted in the Gallery securing a number of important paintings, including Caravaggio's *Boy bitten by*

a Lizard and Bermejo's *Saint Michael triumphs over the Devil*. The Art Fund's continued support has helped the Gallery acquire works such as Altdorfer's *Christ taking Leave of his Mother* and Dürer's *Saint Jerome*. And sizeable grants from the National Heritage Memorial Fund and the Heritage Lottery Fund have enabled the Gallery to purchase paintings such as Seurat's *The Channel of Gravelines, Grand Fort-Philippe* and Stubbs's *Whistlejacket*. Public appeals also continue to help the Gallery enhance the collection, most recently in the cases of Raphael's *The Madonna of the Pinks* in 2004 and Titian's *Diana and Actaeon* in 2009: two more exceptional masterpieces saved for the nation with public support.

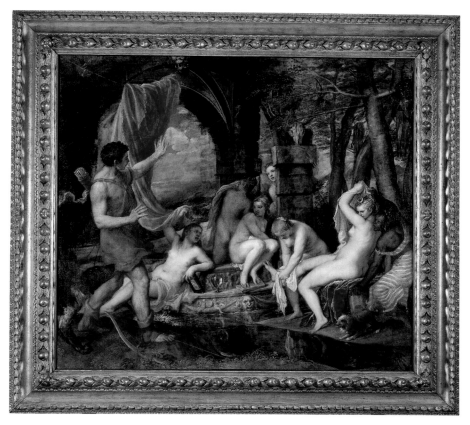

THIS PAGE Titian, *Diana and Actaeon*, 1556–9. Public donations helped secure the painting for £50 million in 2009, when the Titian was purchased jointly by the National Gallery and the National Galleries of Scotland, with contributions from The Scottish Government, the National Heritage Memorial Fund, The Monument Trust and The Art Fund.

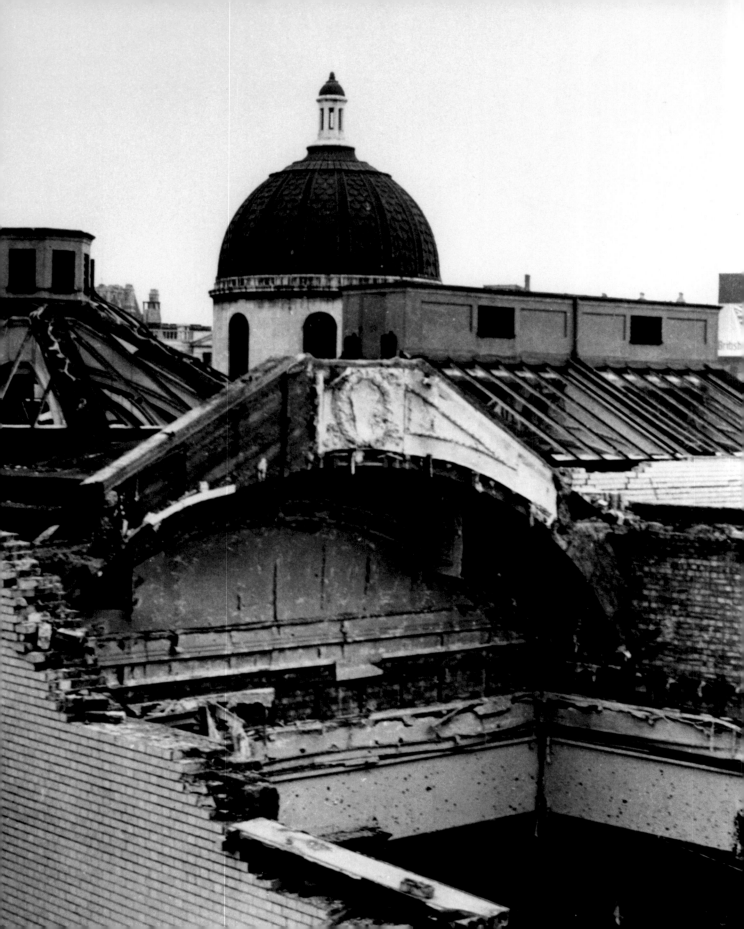

Conflicts and Crises

Safeguarding the national collection was never more perilous than during the twentieth century. From the Zeppelin raids of 1915 to the dark days of the Blitz in 1940, the Gallery was forced to take exceptional measures to protect the paintings. Even when peace returned in 1945, the Gallery remained on a state of alert as the Cold War threatened to draw Britain into a new conflict.

When Britain declared war against Germany on 4 August 1914, the National Gallery had been closed to the general public for two and a half months. It was not the threat of a German attack that had prompted the closure; instead it was an incident that had occurred earlier that year. On 10 March the suffragette Mary Richardson had walked into the Gallery and made her way to Velázquez's *The Rokeby Venus*. Producing a meat chopper from beneath her clothes, she proceeded to attack the painting. Richardson's motive was to highlight the recent arrest of the suffragette leader Emmeline Pankhurst, explaining that she had 'tried to destroy the picture of the most beautiful woman in mythical history because the Government are destroying Mrs Pankhurst, the most beautiful character in modern history'. Richardson was arrested and security increased but this could not prevent a further suffragette attack on 22 May. As a result the Trustees closed the Gallery indefinitely while the situation was assessed. Ironically, it was the start of the First World War and the consequent suspension of militant suffragette activity that enabled the Gallery to reopen on 20 August.

Although the Gallery was to remain open throughout the war, the Trustees were not blind to the dangers of aerial warfare and immediately took steps to safeguard the pictures against damage.

LEFT Rooftop view of the National Gallery, showing extensive bomb damage to Room 10, 1940.

ABOVE The Gallery closed in 1914 following a number of attacks by suffragettes early in the year. Militant protests were widespread as campaigners demanded the emancipation and enfranchisement of women. The Gallery was one of many sites that were targeted by the suffragettes.

RIGHT Aerial warfare reached London for the first time in 1915 when Zeppelin airships bombed the capital. The Gallery took precautionary measures but did not consider that an evacuation of the collection was necessary at this time.

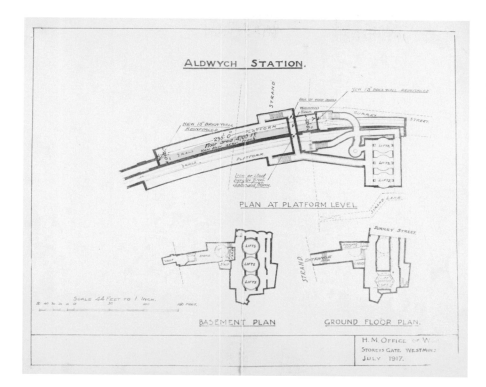

ALDWYCH STATION.

PLAN AT PLATFORM LEVEL

BASEMENT PLAN GROUND FLOOR PLAN.

LEFT In 1917, when Germany's Gotha bombers started aerial bombardments of London, part of Aldwych Tube station was adapted as a secure store to hold some of the Gallery's smaller paintings. However, the Gallery remained open throughout the war.

The structure of the building was reinforced, windows were sandbagged and the most important paintings were removed to the basement. In May 1915 Zeppelin airships launched the first air raids against London causing localised damage and widespread panic. However, evacuation of the collection was still regarded as unnecessary given the existing precautions that had been taken. It was only in 1917 that the situation became more critical when Gotha bombers started to launch raids against London using higher capacity bombs. The Director Charles Holmes decided that urgent action was needed and in July he accepted an offer from the London Electric Railway Company to use a disused part of Aldwych Tube station as a secure store for some of the smaller paintings.

These were moved into the Underground over the next few months, accompanied by armed guards. The following February larger pictures were removed to Overstone Park in Northamptonshire, the home of Lady Wantage, whose father, Lord Overstone, had been a Trustee. She was reassured by Holmes that 'in the course of time their visit to Overstone will become a pleasant incident in the history both of the pictures and the house'. Apart from shrapnel damage in October 1917, the Gallery emerged from the war unscathed. The armistice was declared on 11 November 1918 and within weeks the collection was reunited when the paintings from Overstone and the Aldwych rejoined those that had remained on display in Trafalgar Square.

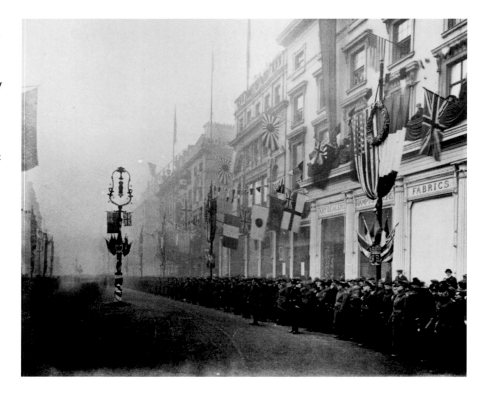

The lessons of the First World War proved instructive and as the international political situation deteriorated during the 1930s, the Government drew up plans to protect the national collection in the event of another conflict. The developments in aerial warfare, which had been seen to such devastating effect at Guernica and Madrid during the Spanish Civil War, meant that any future evacuation would begin as soon as war seemed inevitable. That day came on 23 August 1939 when the Government instructed the Gallery to close its doors and start removing the pictures to safety. Their destinations, known only to a few, included Penrhyn Castle near Bangor, the National Library of Wales in Aberystwyth, and Avening in Gloucestershire, the home of one of the Gallery's Trustees. After only 11 days the final consignment of paintings left Trafalgar Square on 2 September 1939, the day before war was declared on Germany. The Second World War had begun.

Although the immediate danger had passed, the fall of France in June 1940 brought new concerns. The German air force now turned towards Britain and there were fears that a stray bomb could strike one of the Gallery's refuges. The initial response was to disperse the collection further and so spread the risk, but as the paintings would still be vulnerable to bombing this could only ever be a temporary solution. A suggestion had been made that the entire collection should be shipped to Canada for safekeeping but Churchill would have none of it, insisting that Britain should 'hide them in caves and cellars,

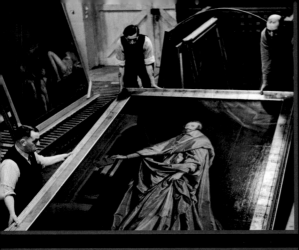
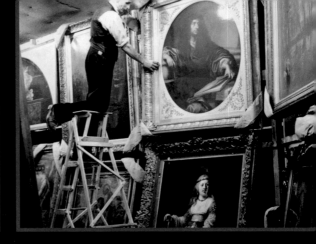
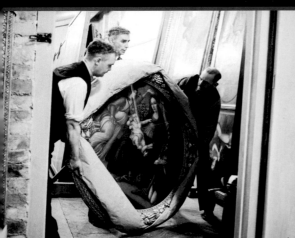
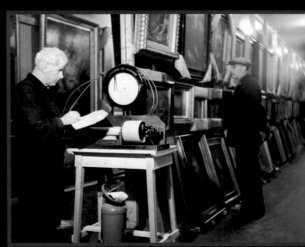
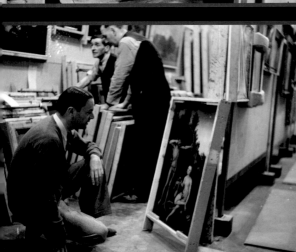

1	2		7	8
3	4		9	10
5	6		11	12

but not one picture shall leave this island'. Therefore in July 1940 the Trustees charged the Gallery's Scientific Adviser, Ian Rawlins, to find underground bomb-proof storage for the paintings. In September of that year Rawlins located the promising site of Manod Quarry, a remote slate mine near Ffestiniog in north Wales. The quarry contained a cave system that ran deep into the mountainside, offering enough space to house the entire collection beneath 200 feet of solid rock. Preparations to adapt the caves for the Gallery's use began almost immediately and took 11 months to complete. The cave floors were levelled, brick storerooms were constructed to house the paintings in a controlled environment, and a railway link was installed to facilitate the movement of the paintings around the caves. The first paintings were transferred to Manod on 12 August 1941 and the operation was completed on 18 September. Supervised by the Gallery's Assistant Keeper (and future Director) Martin Davies and under constant guard, the collection was finally located at a single bomb-proof site.

Back in London, the wisdom of evacuating the collection had been made only too clear when bombing severely damaged the Gallery's west wing. This included the total destruction on the night of 12 October 1940 of Room 10 – the room that had previously housed the Gallery's collection of Raphaels. Despite these dangers, the Director Kenneth Clark was determined that the Gallery should continue to play a part in the cultural life of the capital. Clark both organised and welcomed a variety of cultural events, ranging from the famous Myra Hess music concerts to an ongoing exhibition of paintings by official war artists. In 1942 paintings from the collection also reappeared in the Gallery in the *Picture of the Month* exhibitions. One painting was brought back from Manod every month for display in Trafalgar Square and, although he firmly believed that the boost to public morale far outweighed the risk to the paintings, Clark

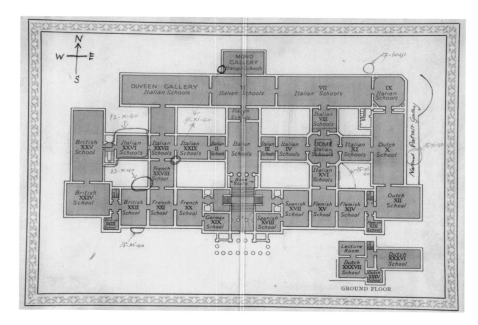

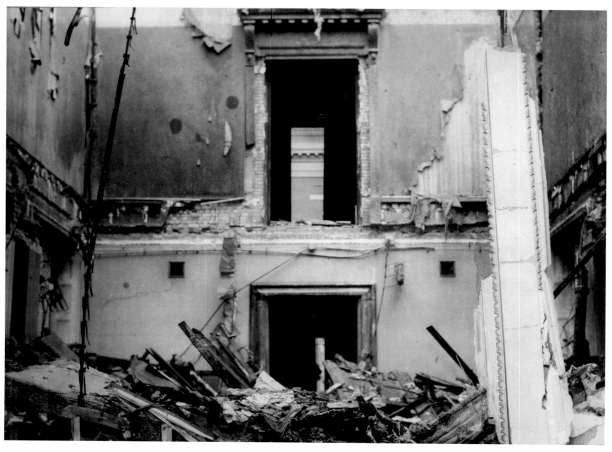

RIGHT **During the Second World War the pianist Myra Hess organised a series of concerts at the National Gallery, which ran from 10 October 1939 until 10 April 1946.**

BELOW **Sir Muirhead Bone (right) selects pictures for an exhibition.**

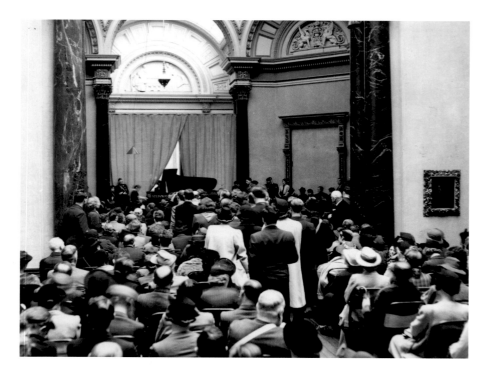

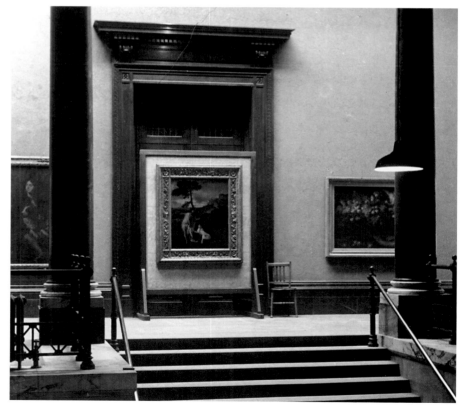

TOP LEFT The display, in 1942, of a new acquisition, *Portrait of Margaretha de Geer* (1661), attributed to Rembrandt, was the forerunner of the *Picture of the Month* exhibitions.

TOP RIGHT AND LEFT The first *Picture of the Month* was Titian's *Noli me Tangere* (about 1514) in March 1942. The displays took place in the west vestibule and were accompanied by minor pictures and an information panel.

ABOVE Visitors return to the Gallery in the weeks following the end of the Second World War.

RIGHT Sir Philip Hendy (1900–1980), Director 1946–67. Hendy's early career included positions at the Wallace Collection, the Isabella Stewart Gardner Museum and the Museum of Fine Arts in Boston. In 1934 he was appointed Director of the Leeds City Art Gallery, a position that he held until he succeeded Kenneth Clark at the National Gallery in 1946.

made sure that every night they were placed in a specially constructed shelter in the basement. The final *Picture of the Month* exhibition closed on 7 May 1945 and the next day crowds gathered outside in Trafalgar Square to celebrate the end of the war in Europe. Three days later Davies sent the following telegram to Clark from Manod: 'Masterpieces will arrive Saturday 12th morning.' The first paintings to be returned to London went on public display on 21 May 1945 and by that December the whole collection was once again back in Trafalgar Square.

The end of the war did not mean the end of Manod as an emergency shelter. In October 1945 Clark argued to the Government that 'there could seldom have been a time when fewer people were confident about the duration of peace, and that being the case it would seem rather absurd to throw away all the money which has been spent on the quarries and have no place to send the pictures when the next war breaks out'. The Government agreed to continue to maintain Manod but there were fears that 'the next war' could be very different to the last. In the age of the atomic bomb the Gallery might have no more than a four-minute warning to evacuate the collection. It was left to Clark's successor,

Philip Hendy, to put together a strategy for ensuring the security of the collection in the event of a nuclear strike. In the worst-case scenario, Hendy planned to use nearby bank vaults to store the most important paintings, believing that these strong-rooms offered 'better protection than anything we have here at present, and if the necessity arose we should prefer to rush a number of pictures through the streets than leave the whole collection here in one place'. Evacuation to Manod would occur if time allowed. Ideally Hendy wanted to see a nuclear shelter built either underneath or adjacent to the Gallery but this was rejected on cost grounds. Only once did these preparations come close to being put into effect when, at the height of the Cold War, the USA and the Soviet Union came to the brink of nuclear conflict during the Cuban Missile Crisis of 1962. As tensions rose around the world, the Gallery had to face the possibility of another evacuation, but this time the paintings remained at Trafalgar Square and the crisis passed. Nevertheless, Manod continued to be retained as a possible wartime repository for a further 20 years and was only decommissioned in 1983, more than 40 years after it had first been used to house the collection in wartime.

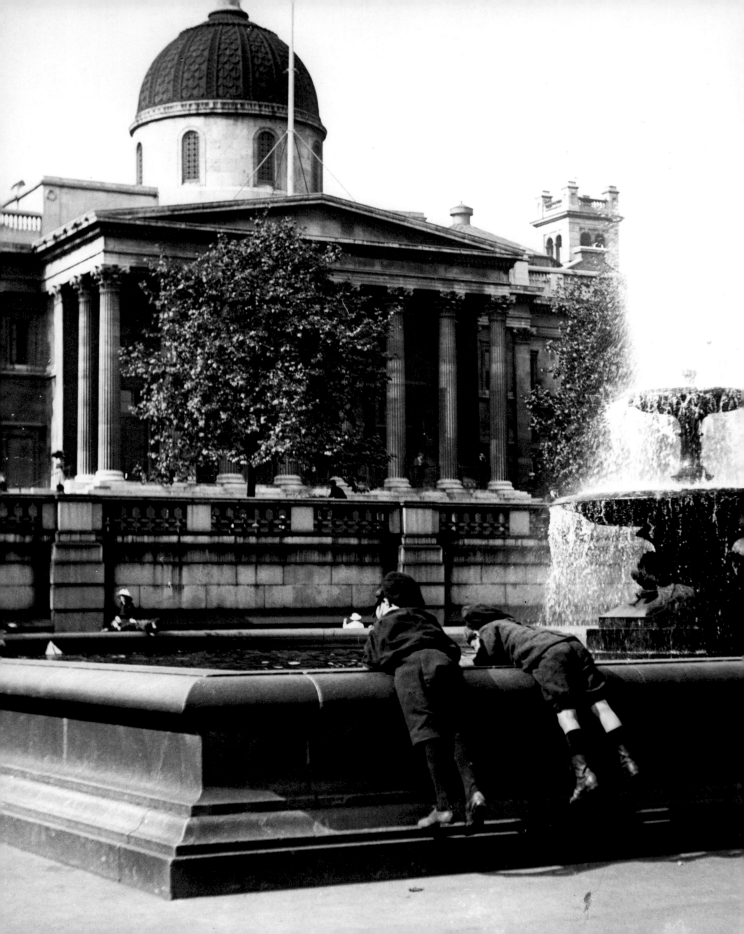

A Much-loved Friend

In the years following the Second World War the National Gallery pursued a building programme of reconstruction, renovation and expansion. The first major extension to the north caused little sensation; in contrast, the second major extension, to the west, was to erupt into one of the most colourful controversies of the 1980s. However, at the end of it all, the entire Gallery building emerged refreshed and rejuvenated as a fitting home for the national collection.

Air raids during the Second World War had severely damaged the west wing of the Gallery and it was not until 1961 that this part of the building was once again fully accessible to the public. Nor did the reconstruction stop there. Following post-war fashions for the display of paintings in a more intimate and neutral environment, alterations continued throughout the 1960s and 1970s: ceilings were lowered; floors were raised; and original architectural features were hidden behind false walls. These changes addressed the aesthetic concerns of the day but the Trustees still had to contend with the old problem of an ever-increasing collection and the corresponding lack of space available for display. It was clear that the Gallery needed to expand.

In 1958 the Government sought to address the Gallery's concerns by acquiring the Hampton site, a vacant plot of land formerly occupied by Hampton's furniture store, at the north-west corner of Trafalgar Square. Although this gave the Gallery a prime location adjacent to the existing building, the Trustees preferred a northern extension towards Orange Street. This would require the demolition of the National Portrait Gallery, which would be compensated with a new building on the Hampton site. Both Galleries could see the merits of the proposal and

LEFT **Two boys playing in the fountain on Trafalgar Square with the National Gallery portico in the background, about 1900.**

OPPOSITE Building work in Room 11 in the 1950s. Damage caused by air raids resulted in reconstruction work, which continued long after the end of the Second World War.

ABOVE With space at a premium, the Conservation Department, established in 1946, was housed in the Gallery's Room 9 until 1960.

LEFT Room 12, displaying Italian Renaissance paintings, was the first gallery to be refurbished and air-conditioned after the war, opening to the public in 1950. One positive aspect of the post-war reconstruction work was that it enabled the Gallery to start the long process of installing air-conditioning throughout the building.

OPPOSITE The reconstruction of the building gave the Gallery the opportunity to complete a major re-arrangement of the collection. As part of the operation (some time during the late 1950s), Director Philip Hendy examines the paintings.

TOP In the 1970s the Gallery sought to conceal original features with raised floors and lowered ceilings. These were intended to enable visitors to enjoy the paintings in a neutral setting without interference from surrounding architecture.

BOTTOM The ground floor was extended during the 1960s to increase the space available for the display of paintings that could not be accommodated on the main floor. Originally known as the Reference Section when it was established by Sir Charles Holmes in 1920, this display had been renamed the Reserve Collection by the time the new rooms opened to the public on 5 June 1964. These rooms now house temporary exhibitions and collection displays, while paintings that cannot be shown on the main floor can be viewed in Room A on the ground floor of the northern extension.

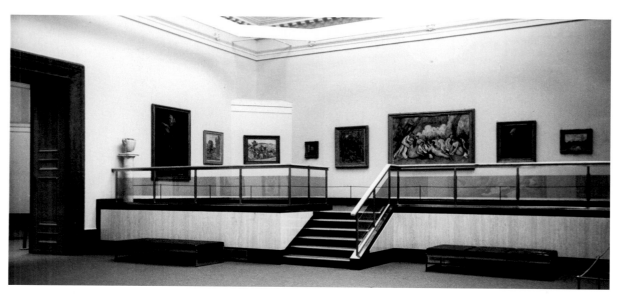

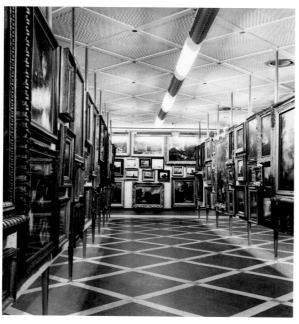

RIGHT The Hampton site, so named because it had previously been occupied by Hampton's furniture store until its destruction during the war in 1940. Situated to the west of the National Gallery, the site was purchased by the Government in 1958 as a possible location for an extension.

BELOW In 1958 *The Sunday Times* launched a speculative competition to design a Gallery extension on the Hampton site. This drawing shows the winning entry by Barrie Dewhurst, who won a first prize of £2,500, but ultimately the site was to be used as a car park until the construction of the Sainsbury Wing in 1988.

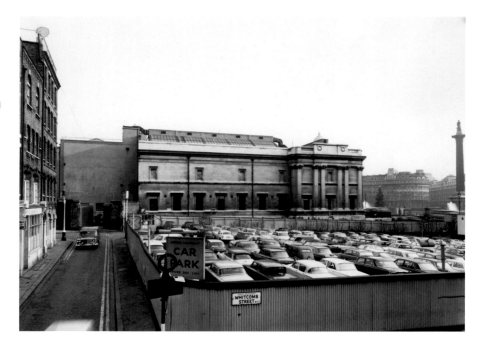

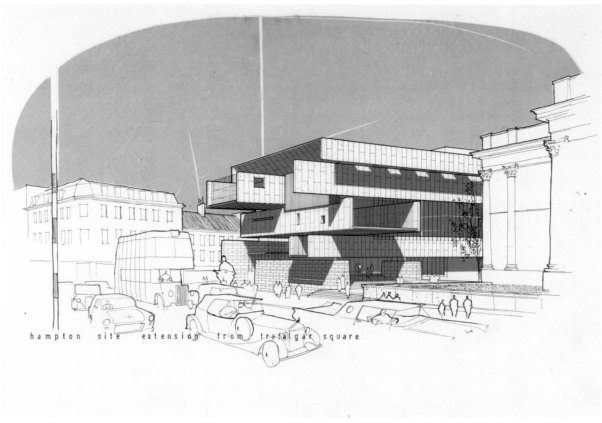

hampton site extension from trafalgar square

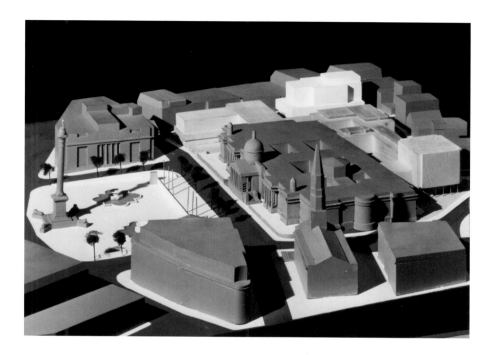

pursued negotiations throughout the 1960s. Although there could be no final agreement until funding had been secured, the National Gallery decided to proceed on the basis that it would one day be able to develop the Portrait Gallery site. Construction work started in 1970 on a northern extension, which the Gallery saw as the first phase of a development ultimately stretching along the entire length of Orange Street. The North Galleries were a major addition to the Gallery when they opened in 1975 and generally received favourable comment. Although one critic had labelled the plans 'neo-bomb-shelter' in design, the *Architects' Journal* praised the completed extension for solving 'the difficult problem of joining together entirely different architectural styles, creating a building both pleasing to look at and comfortable to use'.

However pleasing the North Galleries might have been, they were destined never to be extended any further. The National Portrait Gallery had become steadily less enthusiastic about the prospect of moving and by the early 1980s the Trustees had come to accept that there would be no further expansion of the Gallery along Orange Street. Instead they turned their attention to the still vacant Hampton site. With the Government reluctant to put up public funds for an extension, the Trustees proposed that the site could be developed as a mixture of public and commercial space, the latter paying for the former. The Secretary of State for the Environment, Michael Heseltine, took up the proposal with enthusiasm and in December 1981 he announced an architectural competition that he hoped would attract

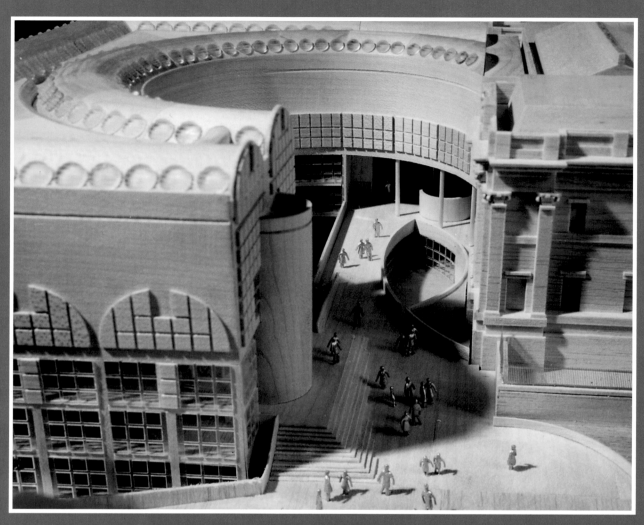

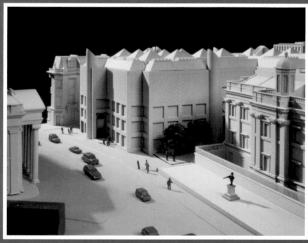

'an imaginative design of the very highest quality'. In August 1982 seven shortlisted designs were put on display in an exhibition that generated a great deal of public and press interest. The designs, however, proved to be less controversial than the competition itself. Accusations were made that the rules of the competition were being changed at the last minute; the Gallery's own preferred architects were discounted; and Heseltine had to step in to proclaim the architects Ahrends, Burton and Koralek the winners when the judging panel rejected all the final designs. Despite working with the Gallery on a new set of plans for almost a year, ABK's revised designs were only finally approved in December 1983, when the Trustees put aside their reservations for fear that an outright rejection of the proposal at this stage would lead to no scheme at all. When the plans were unveiled to the public, a fierce debate ensued about the merits of the proposed extension. Although some believed it was 'a distinguished design', others criticised

it as 'a curious and unsatisfactory compromise'. Its most notable critic was Prince Charles who in May 1984 startled his audience at the Royal Institute of British Architects when he described the scheme as a 'monstrous carbuncle on the face of a much-loved and elegant friend'. The Prince's comments struck a chord with many in the public and press and, although a public inquiry recommended that the scheme should go ahead, in September 1984 a new Secretary of State, Patrick Jenkin, refused planning permission.

One of the major hurdles for the Gallery was finding a happy compromise with the private sector. Neither side could truly achieve what it wanted from the site but both needed each other in order for the development to proceed. It seemed that an impasse had been reached until an outstanding act of philanthropy came to the Gallery's aid. In April 1985 the Sainsbury brothers – John, Simon and Timothy – made one of the most generous gifts that the Gallery has

LEFT Criticism of the revised ABK design recalled the earlier controversy that had dogged Wilkins in the 1830s when the original Gallery building had been erected.

BELOW Model of the selected Sainsbury Wing design by Venturi, Rauch & Scott Brown. The design was made public in 1987.

ever received when they offered to fund the entire extension for the exclusive use of the Gallery. The Trustees gratefully accepted the offer and launched a worldwide search for a new architect to design the extension. After careful consideration, it was announced in January 1986 that Robert Venturi of the firm Venturi, Rauch & Scott Brown had been selected from a shortlist of six architects. The new design was unveiled to the public in April 1987 and work on the new wing started in 1988. Externally the extension complemented the existing buildings on Trafalgar Square, while internally it provided the Gallery with a suite of 16 new rooms for the display of the collection as well as a new bookshop, lecture theatre, seminar rooms, restaurant and temporary exhibition galleries. Named in honour of its donors, the Sainsbury Wing was opened by Queen Elizabeth II on 9 July 1991.

The opening of the Sainsbury Wing coincided with a period when the Gallery as a whole was undergoing a major refurbishment.

This had been launched in 1986 when the Barry Rooms were returned to their original splendour. Works were then carried out throughout the Gallery, removing the false ceilings and raised floors, replacing carpets with hardwood floorings, and restoring the original details of the rooms. The North Galleries were integrated into the overall scheme and the collection was rearranged in order to improve the orientation of the building. Furthermore, the opening of the Getty Entrance in 2004 enabled visitors to enter via the east wing of Wilkins's building at ground level for the first time and offered people improved access from the newly pedestrianised Trafalgar Square. The culmination of all this work took place in 2005, when the painstaking restoration of the original nineteenth-century decorations in the main entrance hall was completed. Restored to its former glory, the Gallery was fit for purpose at the start of the twenty-first century.

RIGHT The restoration in 1986 of the Barry Rooms to their original Victorian splendour marked the start of a major refurbishment of the entire Gallery.

BELOW The ornate decoration of the Barry Rooms includes four reliefs by the sculptor E.W. Wyon. One depicts Queen Victoria. The remaining three represent painting (Raphael and his pupils), sculpture (Phidias before Pericles) and architecture (Michelangelo offering the dome of St Peter's in Rome to the Pope).

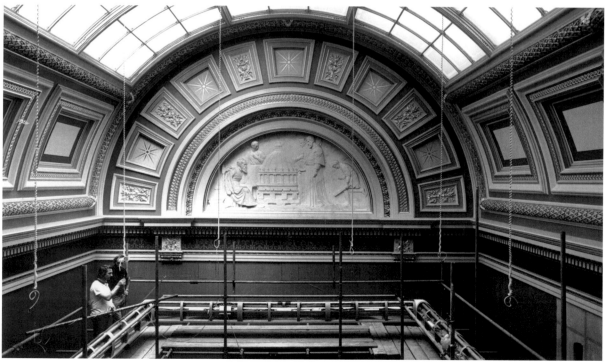

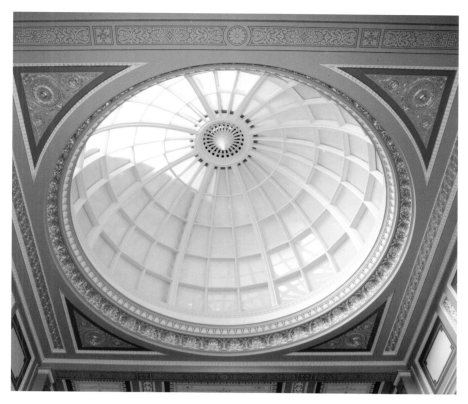

THIS PAGE The refurbished portico entrance is now adorned by a constant supply of fresh flowers from an anonymous benefactor.

Gallery Floorplan

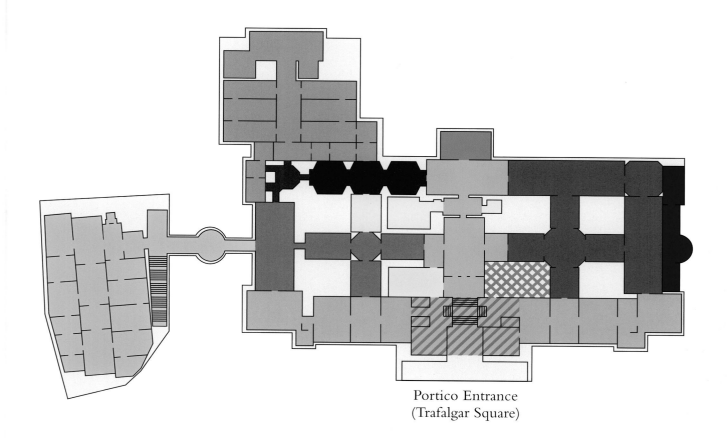

Portico Entrance
(Trafalgar Square)

Wilkins Building 1838
Pennethorne 1861 (now Entrance
 Vestibule)
Barry Rooms 1876
Entrance Vestibule, Central Hall
 and adjoining rooms 1887
National Portrait Gallery 1896
Rooms 5 and 9-12 1911
Mond Room 1928

Duveen Room 1929
Room 14 1937
Room 15 1961
Board Room (now the Portico
 Shop) 1964
North Galleries 1975
Sunley Room 1984
Sainsbury Wing 1991
Getty Entrance and Annenberg
 Court 2004

Keepers and Directors

Established in 1824, the Keeper was the senior officer of the National Gallery until the post of Director was created in 1855.

Keepers

William Seguier (1772–1843)	1824–1843
Sir Charles Lock Eastlake (1793–1865)	1843–1847
Thomas Uwins (1782–1857)	1847–1855

Directors

Sir Charles Lock Eastlake (1793–1865)	1855–1865
Sir William Boxall (1800–1879)	1866–1874
Sir Frederic William Burton (1816–1900)	1874–1894
Sir Edward Poynter (1836–1919)	1894–1904
Sir Charles Holroyd (1861–1917)	1906–1916
Sir Charles Holmes (1868–1936)	1916–1928
Sir Augustus Moore Daniel (1866–1950)	1929–1933
Sir Kenneth Clark (1903–1983)	1934–1945
Sir Philip Hendy (1900–1980)	1946–1967
Sir Martin Davies (1908–1975)	1968–1973
Sir Michael Levey (1927–2008)	1973–1986
Neil MacGregor (b. 1946)	1987–2002
Charles Saumarez Smith (b. 1954)	2002–2007
Nicholas Penny (b. 1949)	2008–present

Further Reading

The National Gallery Archives

Colin Amery, *A Celebration of Art and Architecture*, London 1991

Suzanne Bosman, *The National Gallery in Wartime*, London 2008

Kenneth Clark, *Another Part of the Wood*, London 1974

Kenneth Clark, *The Other Half: A Self Portrait*, London 1977

Jonathan Conlin, *The Nation's Mantelpiece. A History Of The National Gallery*, London 2006

C.J. Holmes, *Self and Partners (Mostly Self)*, London 1936

Sir Charles Holmes and C.H. Collins Baker, *The Making of the National Gallery 1824–1924*, London 1924

Gregory Martin, 'The Founding of the National Gallery in London' in *The Connoisseur*, 1974

Lois Oliver, *Boris Anrep. The National Gallery Mosaics*, London 2004

David Robertson, *Sir Charles Eastlake and the Victorian Art World*, Princeton 1978

Author's Acknowledgements

I wish to thank John Whelan and Victoria Lane for their help and support. I am also very grateful to my colleagues Suzanne Bosman, Elspeth Hector, Susan Foister and the Director of the National Gallery, Nicholas Penny. Many thanks also go to Rachael Fenton and the National Gallery Photographic Department for their dedication and involvement in this project.

Index

This publication is generously supported by a grant from The American Friends of the National Gallery, London, made possible by an anonymous donation to honour the work of Colin McKenzie.

First published in Great Britain in 2009 by
National Gallery Company Limited
St Vincent House · 30 Orange Street
London WC2H 7HH
www.nationalgallery.co.uk

ISBN: 978 1 85709 463 3
525386

British Library Cataloguing-in-Publication Data.
A catalogue record is available from the British Library.
Library of Congress Control Number: 200924275
Publisher Louise Rice
Project editor Claire Young
Editor Lise Connellan
Picture researcher Suzanne Bosman
Production Jane Hyne and Penny Le Tissier
Designer Bianca Ng
Repro DL Repro
Printed in Hong Kong by Printing Express Ltd

National Gallery publications generate valuable revenue for the Gallery, to ensure that future generations are able to enjoy the paintings as we do today.

Front cover: Two boys playing in the fountain on Trafalgar Square with the National Gallery portico in the background, about 1900.
Page 122: H.E. Tidmarsh, *View of Trafalgar Square, from the National Gallery*, painted in the 1880s.

Photographic Credits